POSTCARD HISTORY SERIES

Washington, D.C.
IN VINTAGE POSTCARDS

Washington, D.C.

IN VINTAGE POSTCARDS

Gayle and Dale Floyd

Published by Arcadia Publishing
Charleston SC, Chicago IL, Portsmouth NH, San Francisco CA

Printed in Great Britain

Library of Congress Catalog Card Number: 2005926757

For all general information contact Arcadia Publishing at:
Telephone 843-853-2070
Fax 843-853-0044
E-mail sales@arcadiapublishing.com
For customer service and orders:
Toll-Free 1-888-313-2665

Visit us on the internet at http://www.arcadiapublishing.com

Contents

ACKNOWLEDGMENTS

Dale Floyd took his bride to Washington, D.C., among other historical sites, for her first visit in 1965 while on their honeymoon. Gayle fell in love with the place. In 1969, Dale took a job at the National Archives in Washington, D.C., and they lived in the area for 35 years until a recent move to Charlottesville, Virginia. The couple's twin boys were born in 1969 at Providence Hospital, causing son Eric, who lives in Asia, many woes because he is continually explaining that Washington, D.C., is a separate city, not part of any state.

Both Gayle and Dale revel in Washington history and have spent a great amount of their life visiting the city's sites. Following retirement, Gayle, a school librarian, and Dale, a military historian, became licensed professional tour guides and are members of the Guild of Professional Tour Guides of Washington, D.C. They have also collected Washington-related postcards for many years: Gayle collects general postcards of the area, especially those showing the "first," "largest," or "oldest," as well as others picturing structures that are no more, while Dale specializes in military subjects.

Special thanks to Eleanore Hunter, already the owner of a fine collection of Washington postcards before recently purchasing Gayle's collection, who allowed us to scan hundreds of her cards for the book. The National Building Museum allowed us to peruse its postcard collection and scan certain cards. Fellow tour guides Barbara Troutner and Armen Tashdinian, among others, graciously loaned us cards to scan or outright donated them to use in the book. Thanks also to all who gave us welcome encouragement.

The authors are solely responsible for all errors.

INTRODUCTION

The Residence Act of July 16, 1790, resulted from a political compromise and stipulated that Congress would move to a new capital in 1800. Pres. George Washington selected a site on the Potomac River for the Federal City, determined the locations of government buildings, appointed three commissioners to oversee design and construction, and hired Pierre L'Enfant to design the city and Andrew Ellicott as surveyor. Maryland and Virginia ceded land for the new capital. Construction of the Executive Mansion began in 1792 and of the Capitol in 1793.

In 1800, the government began its move to the new capital, although the government buildings were unfinished, and the city began to grow. During the War of 1812, the British came to town and set fire to the government buildings in 1814 in return for the United States burning the Canadian town of York, now Toronto, the previous year. It later rained and put out the fires, but much damage had occurred; extensive cleanup and renovation were necessary.

At first, the capital had separate governments in Washington City, Georgetown, Alexandria, and Washington County. Eventually, though, the entire district had the same government with elected officials. In the 1840s, Alexandria and the other land on that side of the Potomac River retroceded to Virginia. The district continued to grow as the population in 1860 was 75,080.

As transportation and communications improved, the district witnessed suburban growth, including Homestead in 1851 and Kendall Green in 1854. Improvements such as paved or macadamized roads, streetlights, new trees, and a few sidewalks were accomplished. In spite of these improvements, in 1862, Englishman Anthony Trollope wrote, "Desirous of praising [the city] to some degree, I can say that the design is grand. The thing done, however, falls so indefinitely short of the design that nothing but disappointment is felt."

The Civil War brought many to Washington, including soldiers, sailors, contractors, government employees, escaped slaves, and spies, thereby swelling the population to astronomical numbers. All required food, clothing, and shelter, which were not easily found. The city was constantly under threat of attack, but it was the best-defended city in the world. At the end of the war, some left town but numerous others appeared, thinking that the nation's capital was the place to be.

In 1901, Congress created the Park Improvement Commission of the District of Columbia, headed by Sen. James McMillan. Referred to as the "McMillan Commission," it reviewed, refined, and extended L'Enfant's original plan, given the growth of the city. The commission strove to restore and improve the parks and other open green spaces planned by L'Enfant. One focal point was the reconstitution of the National Mall, an open green space, to highlight the relationship between the Capitol and the Washington Monument.

The capital, for the most part, was a classic Southern town until after World War II. The famous and infamous of the political world inhabited the city. Numerous foreigners came to the city as diplomats, along with their families and hangers-on. Monuments, memorials, and statues dotted

the city. Following World War II, Washington became the capital of the free world. Tourists arrived by the thousands. Tourism is, as it has been for some time, perhaps the second biggest industry in the city, and it brings thousands to Washington every year.

A by-product of Washington tourism is the proliferation of postcards illustrating the various sites in the metropolitan area. Thousands of postcards illustrate the area and document the changes from the turn of the last century to today. This book includes an assortment of postcards, picked for their important site representation, great quality, or distinctive image, that provide a window into Washington history, society, and life. Only certain sites of the city and their history are addressed in this book, for a much larger, multivolume tome would be necessary to cover all.

Because postcards are historical documents, it is important to know when they were issued so one knows how a particular site looked at a specific time. Some cards include dates on them, as well as postmarks, but not all do. To assist in determining a postcard's approximate date, a history of American postcards written by postcard expert John H. McClintock, who has granted permission for its inclusion here, appears below. It delineates the postcard types issued over the years, their special attributes, and the approximate dates of their existence. For additional information about postcards and illustrations of different types, please visit: www.geocities. com/Heartland/Meadows/2487/pchistory.htm and www.rayboasbookseller.com/LINWOOD/ postcardhistory.htm.

Pioneer Era (1893–1898). Most of the earliest postcards date from the Columbian Exposition in Chicago on May 1, 1893. Writing was not permitted on the address side of the cards.

Private Mailing Card Era (1898–1901). On May 19, 1898, private printers were granted permission by an act of Congress to print and sell cards that bore the inscription "Private Mailing Card." Today, we call these cards "PMCs." Postage required was a 1¢ adhesive stamp. A dozen or more American printers began to take postcards seriously. Writing was not allowed on the address side.

Postcard Era (1901–1907). The use of the word "POST CARD" was granted by the government to private printers on December 24, 1901. Writing was still not permitted on the address side. In this era, private citizens began to take black-and-white photographs and have them printed on paper with postcard backs.

Divided Back Era (1907–1914). Postcards with a divided back were permitted March 1, 1907, with the address to be written on the right side and the left side for messages. Many millions of cards were published in this era. Up to this point, most postcards were printed in Germany, who was far ahead of the United States in the lithographic processes. The advent of World War I shifted the supply of postcards to England and the United States.

White Border Era (1915–1930). During this period, most of our postcards were printed in the United States. To save ink, a border was left around the view, thus we call them "White Border" cards. High cost of labor, inexperience, and public taste caused production of poor quality cards. High competition in a narrowing market caused many publishers to go out of business.

Linen Era (1930–1944). A new printing process allowed printing on postcards with high rag content that caused a "linen-like" finish. These cheap cards allowed the use of gaudy dyes for coloring. The firm of Curt Teich flourished on their line of linen postcards. Many important events in history are recorded only on these cards.

Photochrome Era (1945-date). The "chrome" postcards started to dominate the scene soon after they were launched by the Union Oil Company in their western service stations in 1939. Mike Roberts pioneered with his "WESCO" cards soon after World War II. Three-dimensional postcards also appeared in this era.

One

CAPITOL HILL AREA

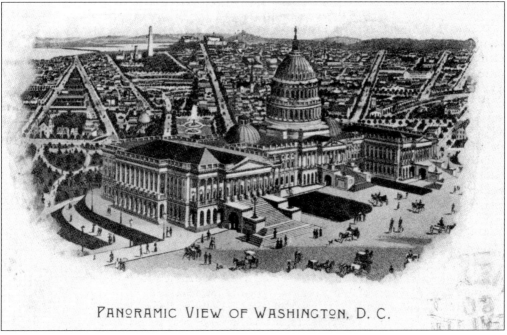

PANORAMIC VIEW OF WASHINGTON, D. C.

This postcard highlights the east front of the Capitol *c.* 1901. William Thornton, the main architect of the Capitol, laid the cornerstone in 1793. The south and north wings (shown here with domes) were constructed first and connected by a wooden walkway in the center area. The "new" House of Representatives (1857) and Senate (1859) are prominent in this view. Charles Bulfinch designed the almost nine-million-pound cast-iron dome, completed in 1863, and he also designed the streetlights. Washington's streets radiate out from the Capitol. The numbered streets run north and south; the lettered streets run east and west. The diagonal streets are named after states. This view looks from southeast of the Capitol toward the southwest on the left and northwest to the right. Northeast would be to the right out of the picture. (Private Mailing Card.)

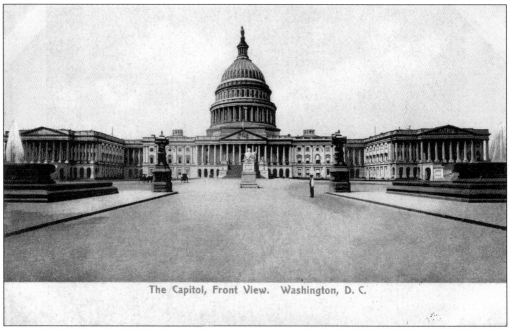

The Capitol, Front View. Washington, D. C.

Horatio Greenough sculpted this statue of George Washington. The reverse of this card reads, "The statue is sculpted from Carrara marble and is 12 feet high." The statue was placed on the east front of the Capitol before the Civil War. In 1908, it was transferred to the Smithsonian Castle and is now on display in the National Museum of American History. (Postcard Era.)

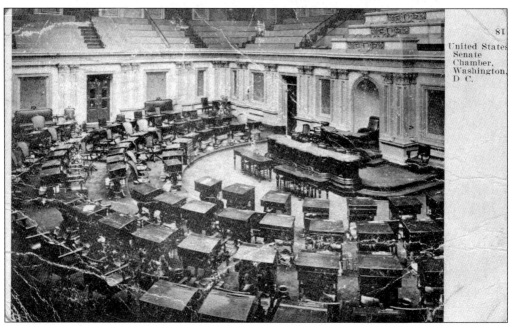

81
United States Senate Chamber, Washington, D. C.

This view of the Senate chamber clearly shows spittoons next to the individual desks. Note that there are more desks than there were senators at the time. Also, notice the Speaker's chair and clerks' desks. (Postcard Era.)

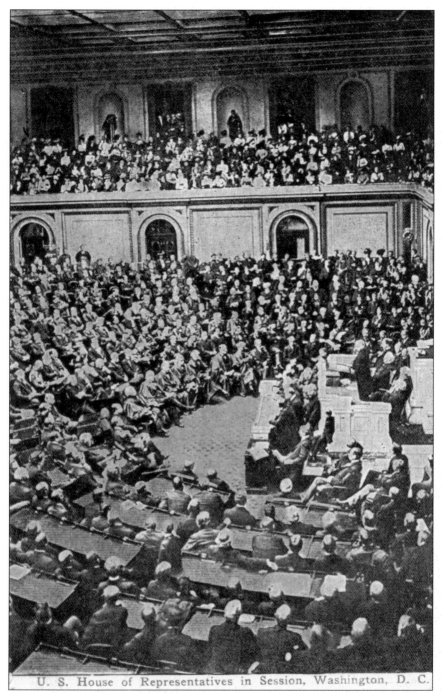

U. S. House of Representatives in Session, Washington, D. C.

The House of Representatives chamber appears on this card. Possibly a State of the Union address is occurring as the Supreme Court Justices are sitting in the front row. The card's reverse side explains, "The dimensions of this hall are 139 by 93 feet, with ceiling 30 feet high. The ceiling of glass panels having the Coat of Arms of each state painted upon them diffuses a soft light throughout the chamber." Each representative had his own mahogany desk, and the Speaker's desk was constructed from white marble. (Postcard Era.)

On the reverse of this card is the following description: "The Senator's Reception Room, known as the Marble Room, because constructed wholly of that material, has stately Corinthian columns of Italian marble, paneled walls of Tennessee marble and ceiling of marble from Vermont." (Postcard Era.)

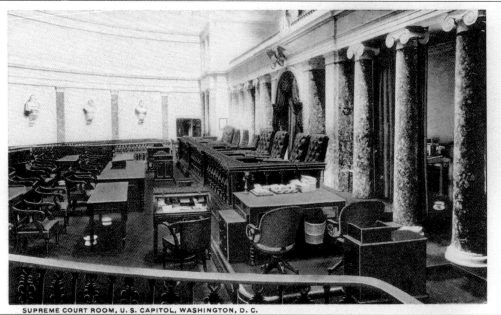

SUPREME COURT ROOM, U. S. CAPITOL, WASHINGTON, D. C.

The reverse side of this card states, "The Supreme Court room was designed by [Benjamin] Latrobe after Greek models. Ranged about the walls is a series of busts of former Chief Justices." A chair was crafted, until recently, specifically for each justice. This room was located in the basement of the Capitol and is now restored to its original appearance. (White Border Era.)

Architect Thomas Hastings designed the first House of Representatives office building, completed in 1908. The reverse side of this card, postmarked 1911, includes the following additional information: "on the left can be seen the New Varnum Hotel, Congress Hall Hotel and the U.S. Grodetic [*sic*] Survey." The building, located between B and C Streets and New Jersey Avenue SE, was later named for Joseph Cannon, former Speaker of the House.

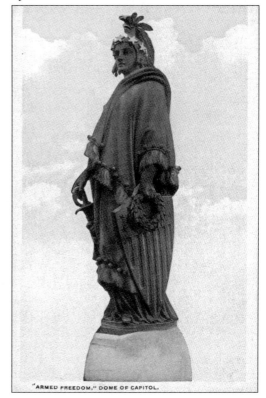

"ARMED FREEDOM," DOME OF CAPITOL.

Notice that the front of this card labels this statue *Armed Freedom*. The reverse side reads, "The bronze statue of Armed Liberty designed by [Thomas] Crawford is 19 feet, 6 inches high and weighs 14,985 pounds. It was set in place on December 2, 1863." "E Pluribus Unum" appears on the globe that supports the statue. She is now called *Freedom*. (White Border Era.)

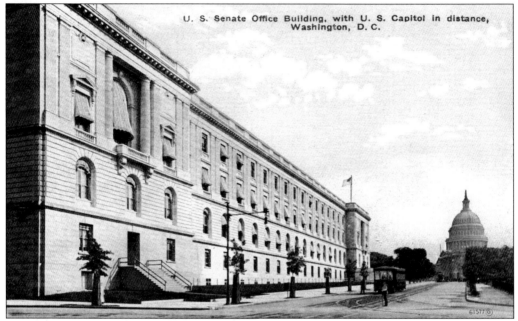

This Senate office building on Delaware Avenue NE looks toward the Capitol. Designed by John Mervin Carrere and opened in 1908, it is now named for Georgia senator Richard Russell. The reverse side of the card declares, "It cost approximately $4,000,000 and the furnishings $300,000." (Divided Back Era.)

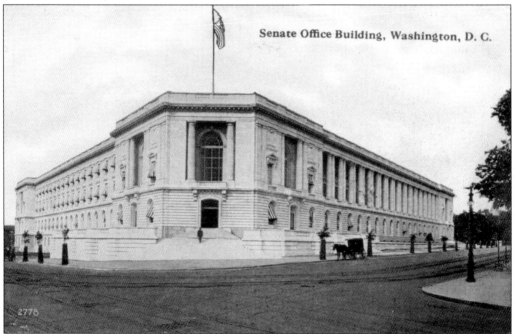

Postmarked 1910, this card provides another view of the Senate office building, viewed from the Senate side of the Capitol. The reverse side of the card states, "White marble building occupies entire block bounded by First, Second, and C Street NE. It is connected with the Capitol by an automobile subway."

This is Gutzon Borglum's bust of Abraham Lincoln, president from 1861 to 1865. The reverse of the card reads, "This colossal marble head of Abraham Lincoln is considered to be one of the best likenesses of the Great Emancipator extant. [It] is considered to be his masterpiece." The statue is still located in the Capitol. (White Border Era.)

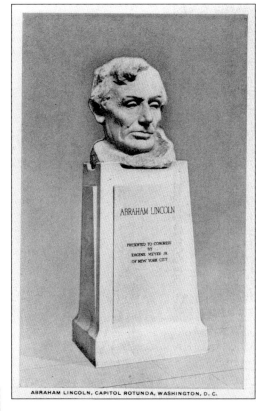

ABRAHAM LINCOLN, CAPITOL ROTUNDA, WASHINGTON, D. C.

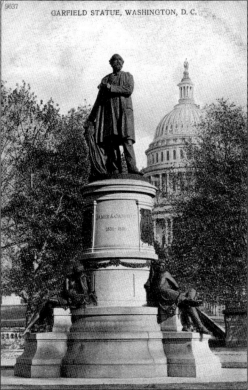

GARFIELD STATUE, WASHINGTON, D. C.

This statue of James A. Garfield, president in 1881, is located on the west side of the Capitol. John Quincy Adams Ward sculpted this statue, erected in 1887. In Garfield's left hand is his inaugural address on which is inscribed "Law, Justice, Prosperity." (Postcard Era.)

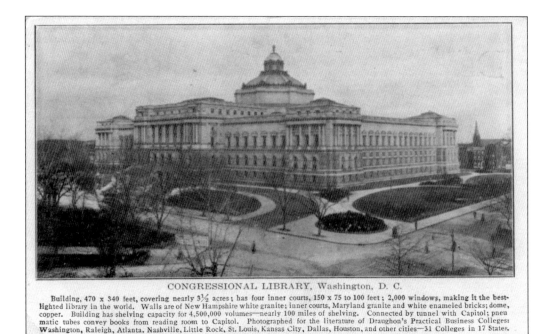

CONGRESSIONAL LIBRARY, Washington, D. C.

Building, 470 x 340 feet, covering nearly 3½ acres; has four inner courts, 150 x 75 to 100 feet; 2,000 windows, making it the best-lighted library in the world. Walls are of New Hampshire white granite; inner courts, Maryland granite and white enameled bricks; dome, copper. Building has shelving capacity for 4,500,000 volumes—nearly 100 miles of shelving. Connected by tunnel with Capitol; pneumatic tubes convey books from reading room to Capitol. Photographed for the literature of Draughon's Practical Business Colleges: Washington, Raleigh, Atlanta, Nashville, Little Rock, St. Louis, Kansas City, Dallas, Houston, and other cities—31 Colleges in 17 States.

The reverse of this card reads: "Jno. F. Draughon's Post Card." (Divided Back Era.)

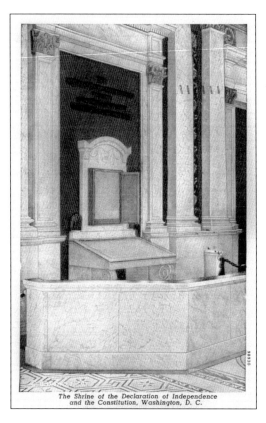

The Shrine of the Declaration of Independence
and the Constitution, Washington, D. C.

The Declaration of Independence and the Constitution, as they were displayed at the Library of Congress, are depicted on this card, postmarked 1947. The caption on the reverse of the card reads, "They have been moved from Library of the State Department. Both papers are protected by a glass which has been chemically treated so as to exclude all injurious light." Today, these documents reside on full display at the National Archives.

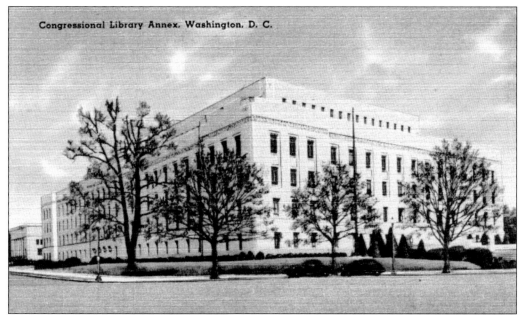

Congressional Library Annex, Washington, D. C.

The reverse of this postcard reads: "The new annex adjoins the Library of Congress at Second and B Sts, S.E. It has shelving space for ten million volumes and combines with the Library of Congress in making the largest library in the world." This annex has since been named the John Adams Building. (Linen Era.)

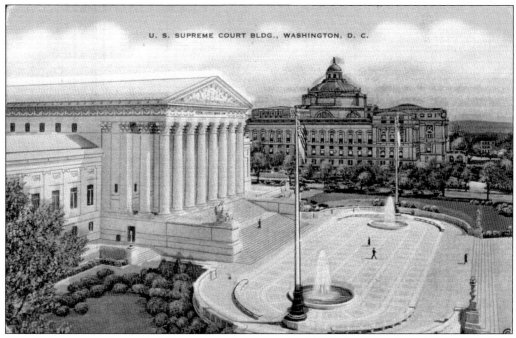

U. S. SUPREME COURT BLDG., WASHINGTON, D. C.

This U.S. Supreme Court Building postcard is postmarked 1937. Architect Cass Gilbert completed the building in 1935 at a cost of $10 million. The postcard's reverse states, "No building approaches it in impressive austerity." (Linen Era.)

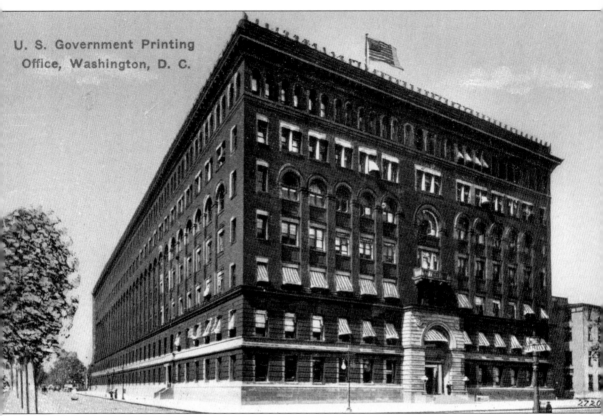

U. S. Government Printing Office, Washington, D. C.

The reverse of this postcard illustrating the U.S. Government Printing Office (GPO) reads, "Located at N. Capital and H Sts., is the largest and finest printing office in the world. It cost more than $2,000,000 and the entire plant is valued at more than $16,000,000. . . . Over 7,000,000 Postal cards have been turned out in one day." (Divided Back Era.)

The Bartholdi Fountain, depicted here in a winter scene, was sculpted in Paris in 1875 by Auguste Bartholdi, sculptor of the Statue of Liberty. (Postcard Era.)

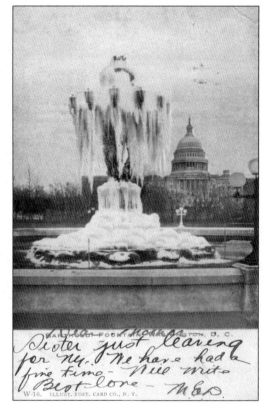

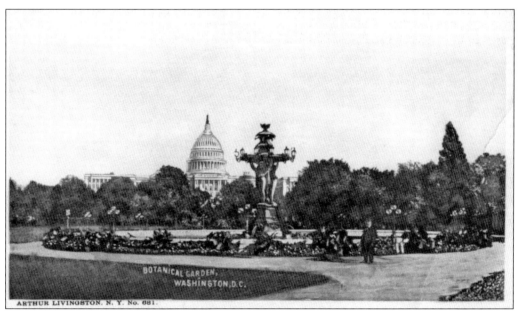

Here are the Bartholdi Fountain and the Botanic Garden in the center of the National Mall in the early 1900s. The fountain and the garden were moved to their present location in 1932. (Postcard Era.)

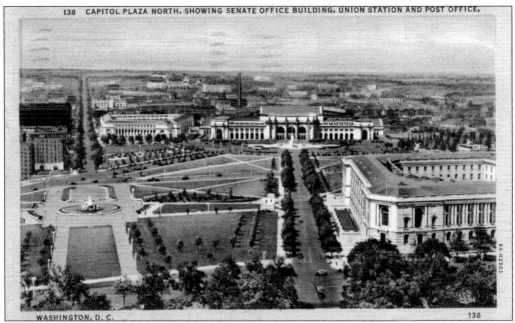

WASHINGTON, D. C. 138

Ernest Graham and Daniel Burnham completed the City Post Office in 1914. Burnham completed Union Station and its plaza in 1908. Lorado Taft designed the Christopher Columbus Memorial Fountain in 1908. (Postcard Era.)

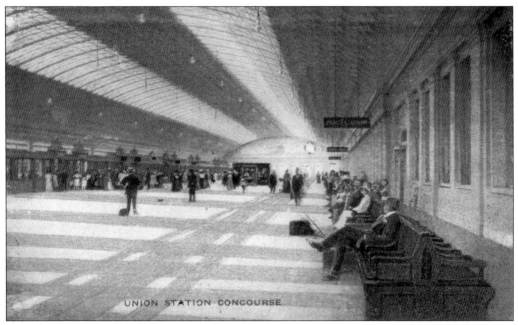

UNION STATION CONCOURSE

This postcard's reverse states, "The passenger concourse of the Union Station, Washington, is notable as being the largest room in the world under a single roof. It is 760 feet in length, comprises 110,200 square feet, and would hold an army 50,000 strong." (Linen Era.)

Two

WHITE HOUSE AREA

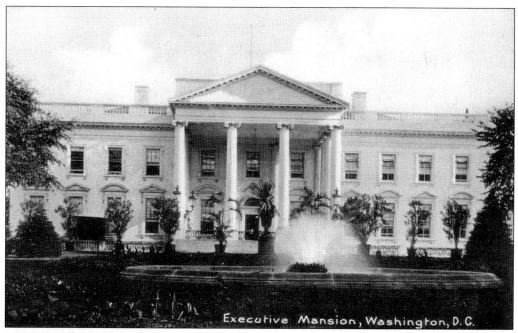

Executive Mansion, Washington, D. C.

The north front of the president's house, located at 1600 Pennsylvania Avenue, is referred to as the Executive Mansion on this card. John Adams, the second president (1797–1801), moved into the mansion, which was far from finished, in 1800. Architect James Hoban designed the building. Theodore Roosevelt, the 26th president (1901–1909), was the first to officially use stationery with the heading "The White House." (Postcard Era.)

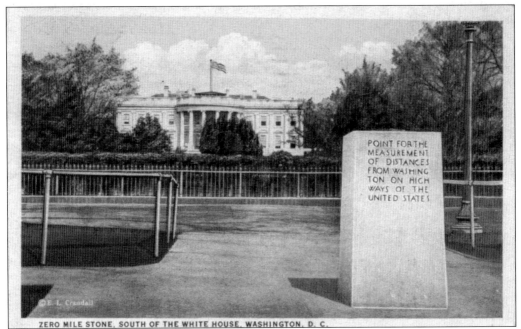

ZERO MILE STONE, SOUTH OF THE WHITE HOUSE, WASHINGTON, D. C.

The caption on the reverse of this card, postmarked 1929, reads, "[The Zero Milestone] was unveiled by President Harding [1921–1923], [and] it is measuring point for distances by automobile to any designated Point in the United States." The four-foot-high, pink granite Zero Milestone was unveiled on July 4, 1923.

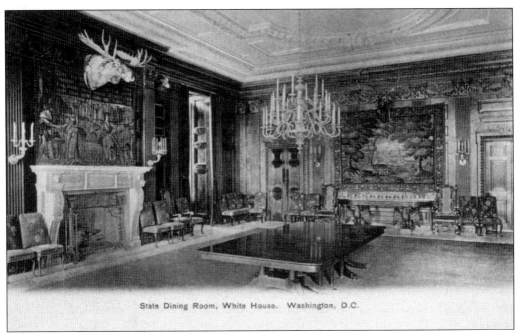

State Dining Room, White House. Washington, D.C.

The State Dining Room looked like this in the early 1900s. Theodore Roosevelt, who was president then, was an avid hunter. (Postcard Era.)

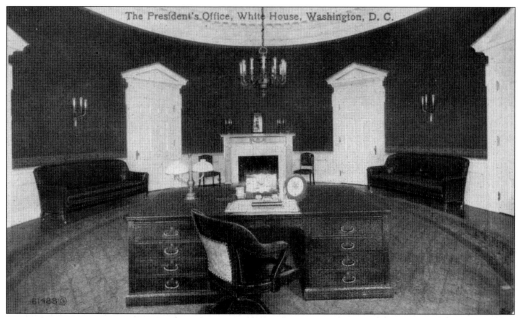

This postcard's reverse explains, "The President's Office is separated from the White House by an esplanade. It is one of the busiest places in the government service, for here audiences are given, bills of Congress are signed and the daily routine of the greatest governmental undertaking in the world, carrying with it an annual expenditure of nearly a billion dollars, is performed." (Postcard Era.)

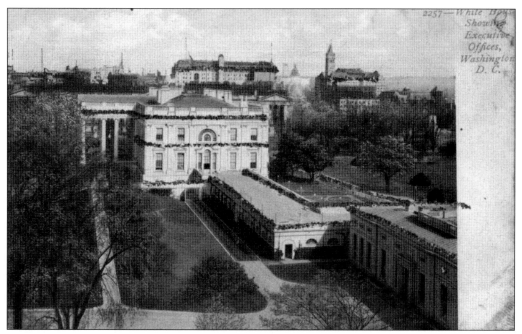

Until the early 1900s, the president's office was in the residence. McKim, Mead, and White, an architectural firm, added the president's office to the White House in 1902 when Theodore Roosevelt desired more space. Now this area is known as the West Wing.

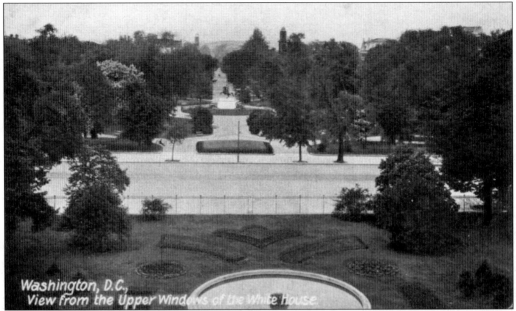

This unusual postcard gives us a view from the upper windows of the White House looking toward the north (Pennsylvania Avenue and H Street). Andrew Jackson's statue is clearly visible in Lafayette Park.

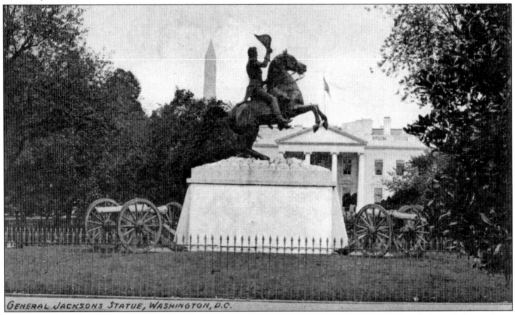

Postmarked 1918, this postcard of the Andrew Jackson statue shows the north front of the White House and the Washington Monument. The reverse states, "The statue of Gen. Andrew Jackson is located in the centre of Lafayette Square, opposite the White House. It is molded from guns he captured in the war of 1812, and the mounted cannons at its base saw service during the same period. It is poised with the aid of iron devices or rods, the hind parts and the tail of horse being solid. It weighs 15 tons and cost $50,000. Sculptor Clark Mills." The statue was placed in Lafayette Park in 1853.

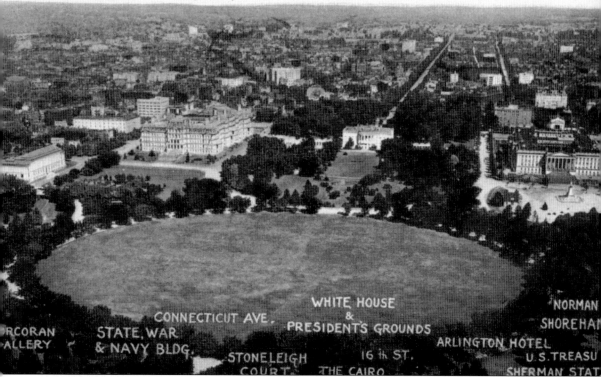

CORCORAN
GALLERY STATE, WAR
 & NAVY BLDG. CONNECTICUT AVE. WHITE HOUSE
 &
 PRESIDENT'S GROUNDS NORMAN
 STONELEIGH SHOREHAM
 COURT. 16 th ST. ARLINGTON HOTEL
 THE CAIRO U.S.TREASU
 SHERMAN STAT

This aerial view of the White House area is postmarked 1911. Some of these buildings have
since been razed.

25

The Blair house, built in 1824 by the first surgeon general, Gen. Dr. Joseph Lovell, is illustrated on this card, postmarked 1951. In 1837, Francis Preston Blair, a Kentuckian who made a great deal of money in real estate, bought the house. Kinsman Montgomery Blair, the attorney who represented Dred Scott and later was postmaster general under Abraham Lincoln (1861–1865), inherited it. The Lee family owned the adjacent house, and it was here that Robert E. Lee was offered and refused command of the Union troops in 1861. President Truman (1945–1953) and his family lived at the residence while the White House was undergoing major renovations. A postcard still cost a penny to mail during this period. (Linen Era.)

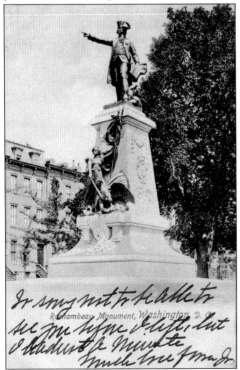

The bronze statue of Maj. Gen. Comte Jean De Rochambeau, the commander of a 5,500-member Royal French Expeditionary Force, is one of four foreign heroes who aided the United States during the Revolutionary War honored in a corner of Lafayette Park. It is located on Pennsylvania Avenue with the Jackson Place homes of the period in the background. This monument, sculpted by J. J. Ferand Hamar, was placed here in 1902.

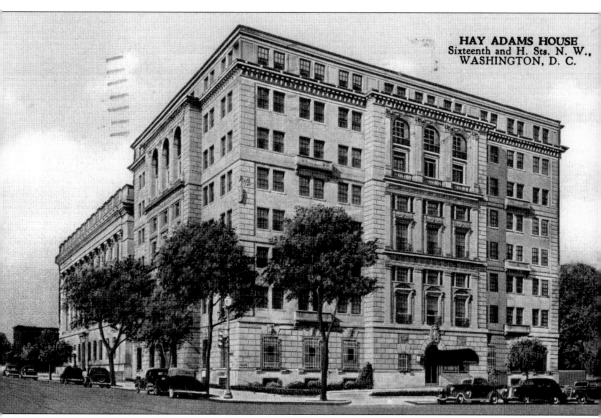

Mihran Mesrobian built the Hay-Adams House (800 Sixteenth Street) in 1926–1927. It replaced architect H. H. Richardson's adjoining houses that he built for John Hay and Henry Adams in 1885. The reverse of this postcard reads, "Hay Adams House—All bedrooms Air Conditioned. At the corner of Sixteenth and H Streets overlooking the White House across beautiful Lafayette Square, in the heart of the Capital's exclusive social and official life and ideally situated in its accessibility to the many vacation pleasures that Washington offers." (Linen Era.)

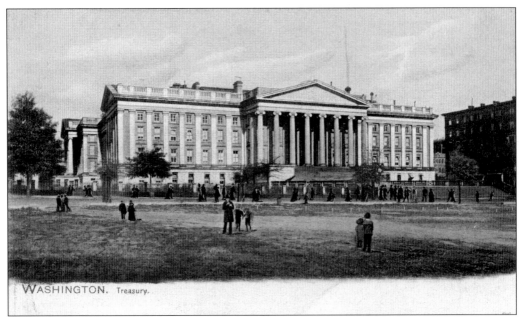

WASHINGTON. Treasury.

Tuck's Publishing Company (Raphael Tuck and Sons, art publishers to the king and queen of England) released this view of the Treasury Department. Robert Mills designed this sandstone and granite building, located at 1500 Pennsylvania Avenue, in 1836. It was referred to as a "banker's bank." (Postcard Era.)

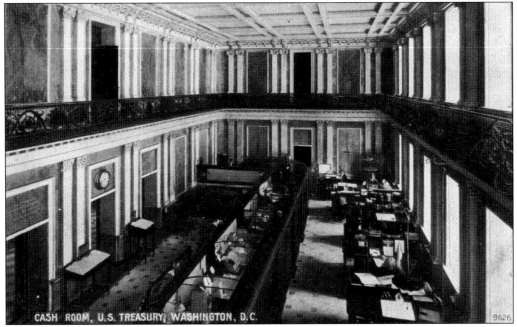

CASH ROOM, U.S. TREASURY, WASHINGTON, D.C. 9626

The marble Cash Room of the United States Treasury opened in June 1869. Alfred B. Millet designed this room. This picture was probably taken in the early 1900s, when horse-drawn carriages would bring the gold, silver, and paper money, intended for storage in the Cash Room, to the Fifteenth Street entrance of the Treasury Building. It was hauled by hand carts and then lowered by the cargo-lift to the Cash Room. The room closed June 30, 1976.

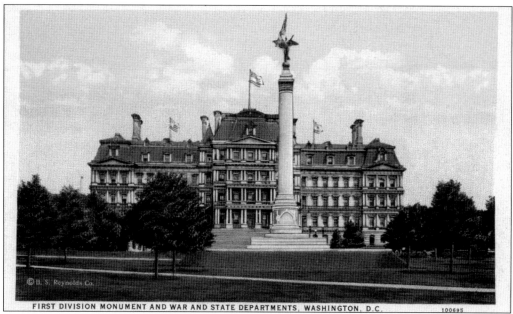

FIRST DIVISION MONUMENT AND WAR AND STATE DEPARTMENTS, WASHINGTON, D.C.

Printed on the reverse side of this postcard is: "The First Division Monument. A beautiful white granite shaft surmounted with a gold statue of Victory, by Daniel Chester French, was erected to commemorate the heroic deeds of the A. E. F. in the World War. It was erected by the Memorial Association of the First Division and its friends." The monument is located on the south side of the War and State Departments. (Divided Back Era.)

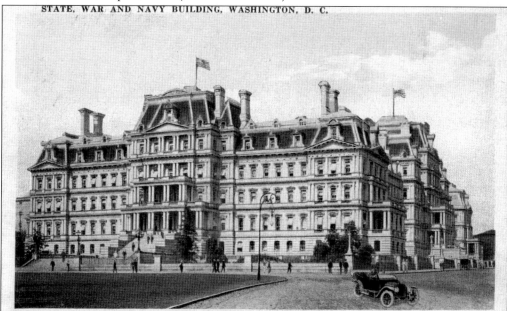

STATE, WAR AND NAVY BUILDING, WASHINGTON, D. C.

The reverse of this postcard proclaims: "The State, War and Navy Building with a frontage of 342 feet on Pennsylvania Avenue, and a depth of 565 feet, ranks as one of the largest and most magnificent office buildings in the world. It has 500 rooms and two miles of marble halls." This rendering shows an edifice built between 1871 and 1888 that was designed by architect Alfred B. Mullett. (Divided Back Era.)

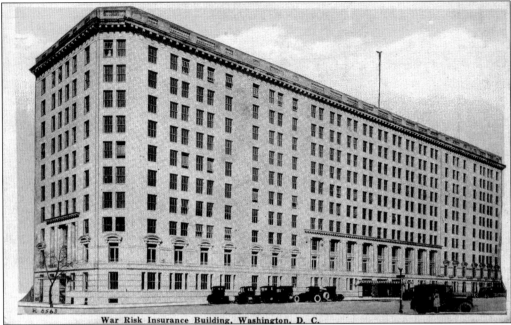

War Risk Insurance Building, Washington, D. C.

The description on the back of this postcard reads: "THE BUREAU OF WAR RISK INSURANCE [a branch of the United States Treasury] is erected on the site of the historic Arlington Hotel at Vermont Avenue and H Sts. N.W. It is one of the government's largest office buildings and houses over ten thousand employees whose duties are in reference to soldiers and sailors insurance claims, allotments, etc. growing out of late World War. The sum of money received and disbursed by the War Risk Bureau has run into billions." (Divided Back Era.)

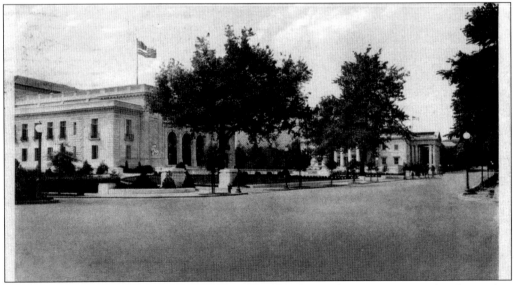

The Pan American Union (now called the Organization of American States) is located at Seventeenth Street and Constitution Avenue. Albert Kelsey and Paul P. Cret built it in 1910, and Gertrude Vanderbilt adorned it with many sculptures. Andrew Carnegie partly funded this building to headquarter an organization promoting peaceful relations among the nations of North, Central, and South America.

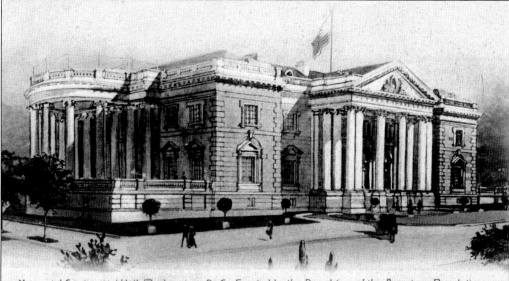

Memorial Continental Hall, Washington, D. C. Erected by the Daughters of the American Revolution.

Memorial Continental Hall is "a beautiful white marble building . . . erected by the National Society of the Daughters of the American Revolution [and] completed in 1910 at a cost of over $500,000." The portico on the left has 13 columns representing the 13 original states. The DAR, a nonprofit organization founded in 1890, is dedicated to promoting education and patriotism within a historic preservation framework. Members, women only, must be blood related to someone who fought in or aided the Revolution.

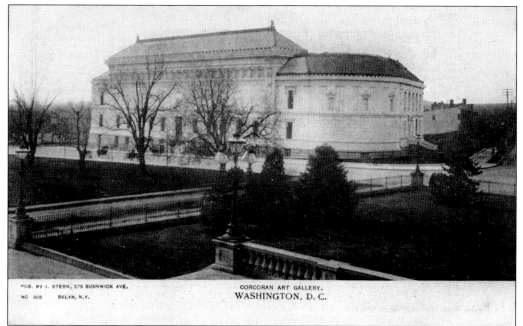

PUB. BY I. STERN, 578 BUSHWICK AVE.
NO 308 BKLYN, N.Y.

CORCORAN ART GALLERY.
WASHINGTON, D. C.

Ernest Flagg designed the Corcoran Gallery of Art, located at Seventeenth Street and New York Avenue NW, which opened in 1897. This Beaux-Arts building was actually the second Corcoran Gallery of Art; the first one is now the Renwick Gallery, located on Pennsylvania Avenue. (Postcard Era.)

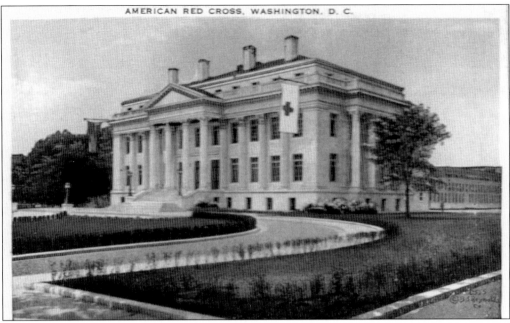

The Red Cross Building at 1730 E Street NW was completed in 1929. Clara Barton, known as the "angel of the battlefield" during the Civil War, founded the American Red Cross.

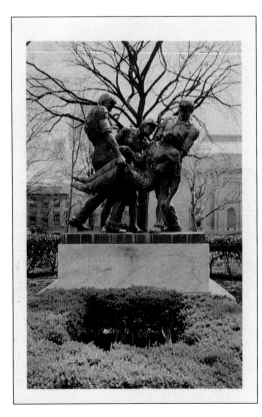

Felix deWeldon sculpted the statue dedicated to the Red Cross men and women killed in service. It appears on this real–photo postcard, postmarked 1959. The seven-foot statue is in the garden of the American Red Cross Building located at D Street between Seventeenth and Eighteenth Streets NW.

Three

PENNSYLVANIA AVENUE
AREA

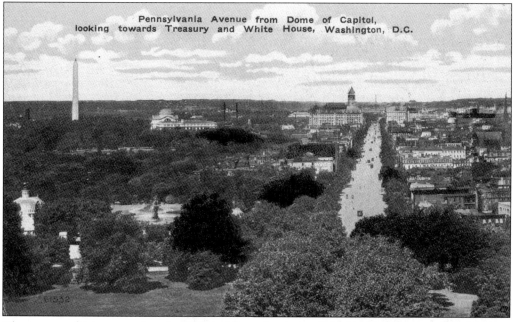

Pennsylvania Avenue from Dome of Capitol, looking towards Treasury and White House, Washington, D.C.

The reverse of this postcard reads, "Viewed from the dome of the Capitol, the city of Washington looks like a vast forest studded with villas, for fully 100,000 trees adorn its parks and line its streets. The densely wooded area to left of the picture is the Mall wherein are located the Medical and National Museums, The Smithsonian Institution, the Agricultural Dept., The Bureau of Printing and Engraving and the Washington Monument. The open space is Pennsylvania Avenue from the Peace Monument to the United States Treasury. The larger building on left with tower is the Post Office."

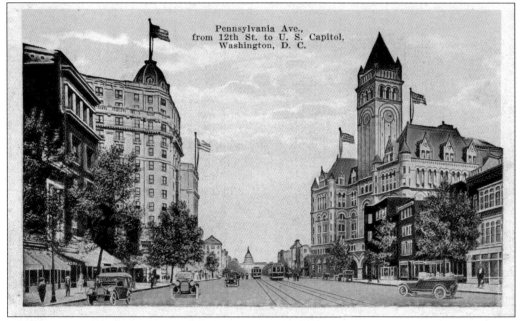

This early-1900s postcard proclaims, "Pennsylvania Avenue is the most historic thoroughfare in America. Over it have passed funeral corteges of each of our martyred Presidents. . . . It is the route of parade at each Presidential Inauguration, when thousands of citizens come from every state to partake of the Festivities." Pennsylvania Avenue runs from the Capitol to Fifteenth Street NW, where it becomes E Street. Two blocks north, Pennsylvania Avenue continues west, past the Executive Mansion, until it merges with M Street NW. This street scene shows a variety of government buildings, housing, retail stores, and hotels. (Divided Back Era.)

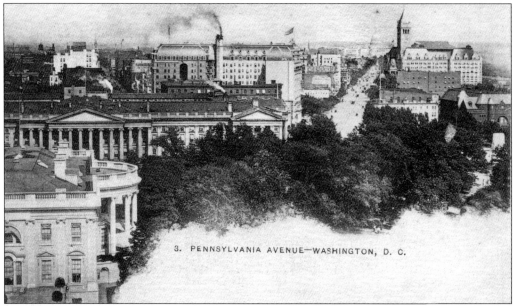

This early postcard view of Pennsylvania Avenue looks toward the Capitol. It shows the south portico of the White House, a clear view of the west side of the Treasury Department, the Willard Hotel on the left, and the City Post Office on the right. (Postcard Era.)

A view from the Post Office Tower looking northwest highlights Pennsylvania Avenue. Most of these buildings have since been torn down. Architect Willoughby J. Edbrooke designed the post office building and the 315-foot tower, completed in 1899. The post office and tower have survived urban renewal due to heroic efforts accomplished principally by Nancy Hanks during the 1970s. (Postcard Era.)

This early-1900s view shows various modes of transportation in the city.

35

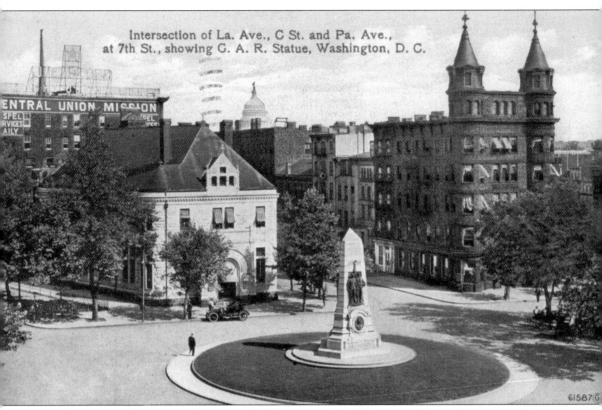

Intersection of La. Ave., C St. and Pa. Ave.,
at 7th St., showing G. A. R. Statue, Washington, D. C.

The reverse of this postcard, postmarked September 11, 1914, reads, "Pennsylvania Ave., C Street and Louisiana Avenue intersect at 7th Street. Here is located the Monument in honor of the Grand Army of the Republic and its organizer Benj. Franklin Stephenson, M.D. The electric sign over the Central Union Mission Building is particularly impressive against the sky at night." The Central National Bank converted the twin-towered Apex Building, shown on the right, from a hotel in 1887. The white building was the National Bank of Washington, designed by architect James G. Hill in 1889. This part of Louisiana Avenue is now Indiana Avenue.

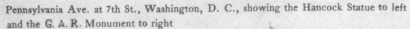

Pennsylvania Ave. at 7th St., Washington, D. C., showing the Hancock Statue to left and the G. A. R. Monument to right

This view shows the commercial trade (Kann's and Sak's) in the area. To the right is the monument honoring the Grand Army of the Republic, and to the left is a statue honoring Union army major general Winfield Scott Hancock at the Battle of Gettysburg. Notables such as Pres. Grover Cleveland and Vice Pres. Adlai E. Stevenson attended the Hancock statue's 1896 dedication. Kann's burned in 1979.

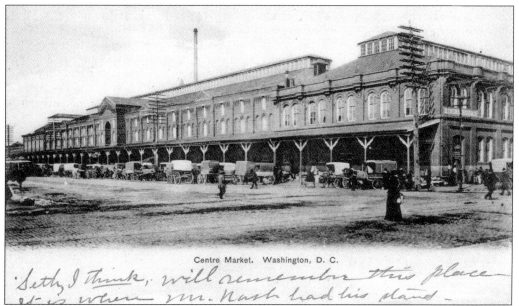

Centre Market. Washington, D. C.

Seth, I think, will remember this place it is where mr. Nash had his stand —

On the south side of Pennsylvania Avenue between Seventh and Ninth Streets NW sits the Center Market. A market operated here from 1801 until it was demolished in 1931. This market was built in 1872 after an open sewer next to the Washington Canal was filled in. The view on Constitution Avenue is from the early 1900s, when over 900 vendors could be accommodated in the space. The National Archives occupies this space now.

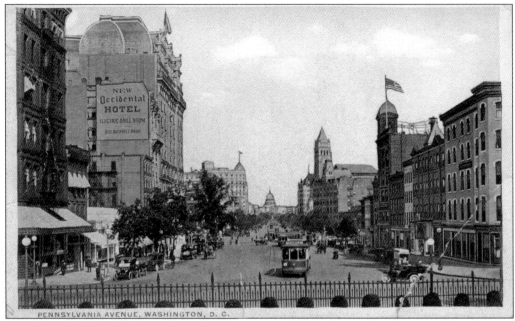

PENNSYLVANIA AVENUE, WASHINGTON, D. C.

This is a favorite place for postcard photographers. Looking from the Treasury Building directly at the Capitol, this early photograph shows the first-floor retail shops and the Occidental Hotel, which has an Electric Grill room, on the left. On the right are office buildings and the post office (since torn down and replaced by a "new" post office and the Ronald Reagan Building). The Renaissance Revival Southern Railway Building is prominent on the southeast corner of Pennsylvania Avenue and Thirteenth Street NW.

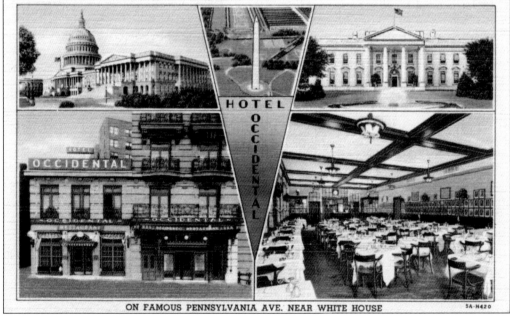

ON FAMOUS PENNSYLVANIA AVE. NEAR WHITE HOUSE 5A-H420

The Occidental Hotel, located at 1411 Pennsylvania Avenue NW, displays its amenities from within and without. The proprietors, Gus Bucholz and sons, "would rather serve lots of people at a small profit than a few people at a large profit." (Linen Era.)

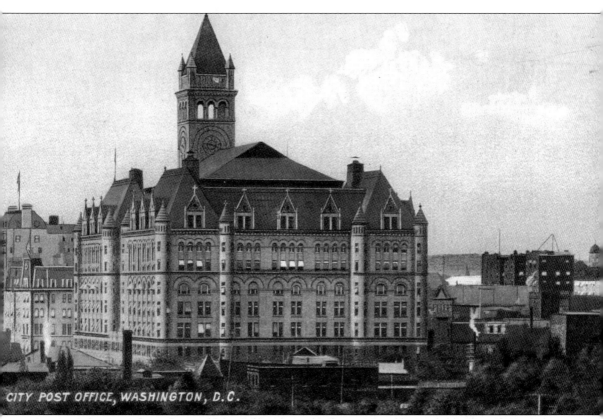

CITY POST OFFICE, WASHINGTON, D.C.

Completed in 1899 under the supervision of Willoughby J. Edbrooke, the City Post Office and 315-foot clock tower command an imposing view at Twelfth Street on Pennsylvania Avenue. The building was the first major steel-framed structure in Washington. This building survives today. (Postcard Era.)

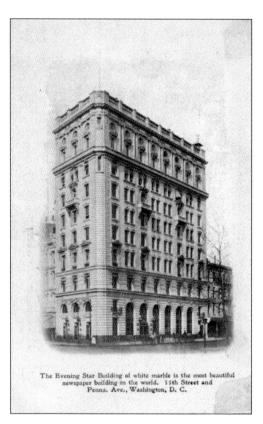

The Evening Star Building of white marble is the most beautiful newspaper building in the world. 11th Street and Penna. Ave., Washington, D. C.

The architectural firm of Marsh and Peter designed this ten-story Beaux-Arts Evening Star Building, located at 1101 Pennsylvania Avenue NW, in 1898. The *Evening Star* newspaper was founded in 1852.

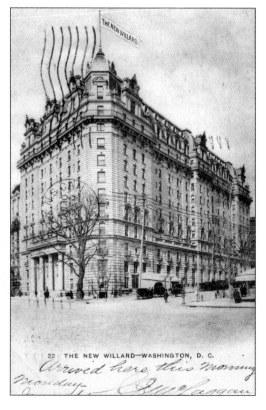

22 THE NEW WILLARD—WASHINGTON, D. C.

A hotel named after entrepreneur James Willard has been on this site since 1847. Henry Hardenbergh supervised the construction of this particular structure between the years 1901 and 1904. (Postcard Era.)

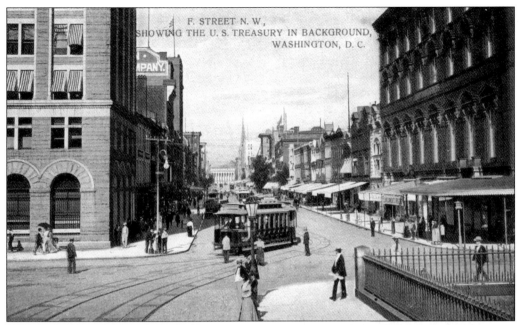

Moving north a block, F Street NW boasts its share of fine shops and hotels. This early-1900s postcard view shows a lot of activity.

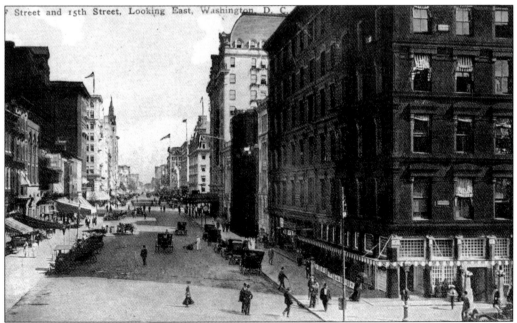

The description on the reverse of this postcard explains: "[F Street] from 15th can be seen running east with the famous Café Republique on the corner. The New Willard and New Ebbitt hotels are on the same street and below is Washington's Bon Ton Shopping District." (Divided Back Era.)

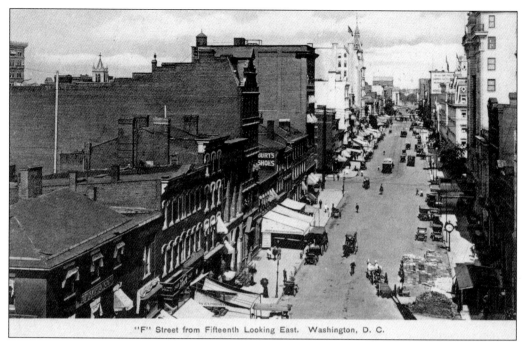

This early-1900s postcard illustrates the hustle and bustle of F Street. (Postcard Era.)

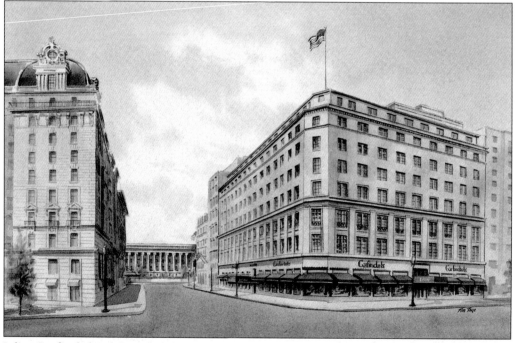

Julius Garfinckel and Company Department Store at Fourteenth and F Streets NW is featured on this postcard. Starrett and van Vleck erected the building in 1930. Its clientele included matrons with hats and white gloves as part of their attire. (Linen Era.)

Located at F and Twelfth Streets NW, Brentano's bookstore graced a simple building of the early 1900s. This is a good example of an advertising postcard.

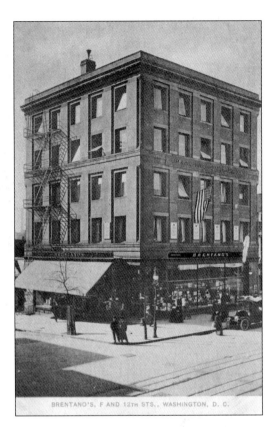

BRENTANO'S, F AND 12TH STS., WASHINGTON, D. C.

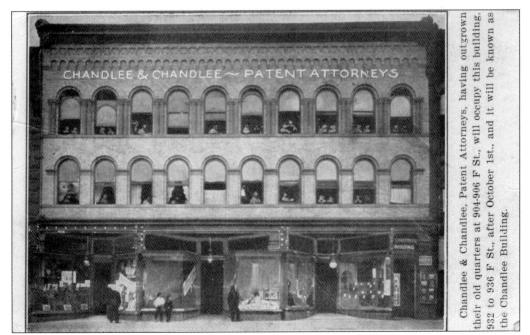

CHANDLEE & CHANDLEE ~ PATENT ATTORNEYS

Chandlee & Chandlee, Patent Attorneys, having outgrown their old quarters at 904-906 F St., will occupy this building, 932 to 936 F St., after October 1st., and it will be known as the Chandlee Building.

Featured on this advertising postcard, 936 F Street demonstrates good use of office space above what could be retail stores on the ground level.

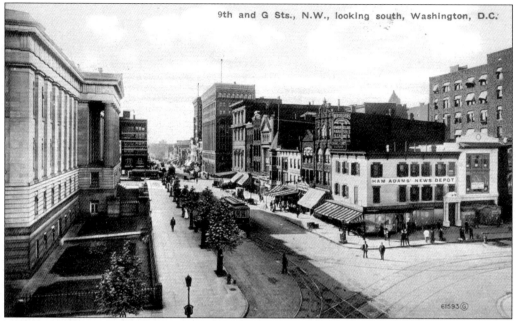

9th and G Sts., N.W., looking south, Washington, D.C.

Stated on the reverse of this postcard is: "A view is here shown of 9th looking south from G. Left is the Interior Dept. wherein is located the U.S. Patent Office. The large building on the right on far side of the first street crossing [F St] is the Washington Loan and Trust Company's. The Warder and Inter-Ocean Buildings, the Maryland, Virginia, Gayety, Leader, Plaza, Imperial Empress, Academy of Music and Palace Theatres are also in the street between G Street and Pennsylvania Ave."

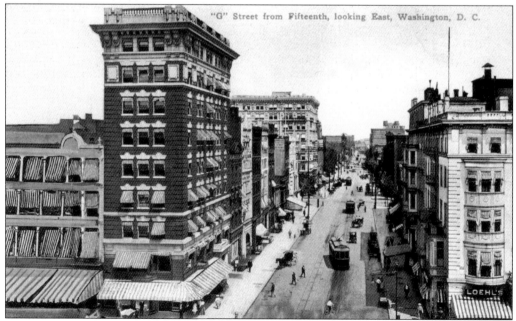

"G" Street from Fifteenth, looking East, Washington, D. C.

The description on the reverse of this postcard reads, "G Street and 15th Street—This shows G Street From the United States Treasury. On this street will be found two of our leading Department stores, as well as numerous other business houses." (Divided Back Era.)

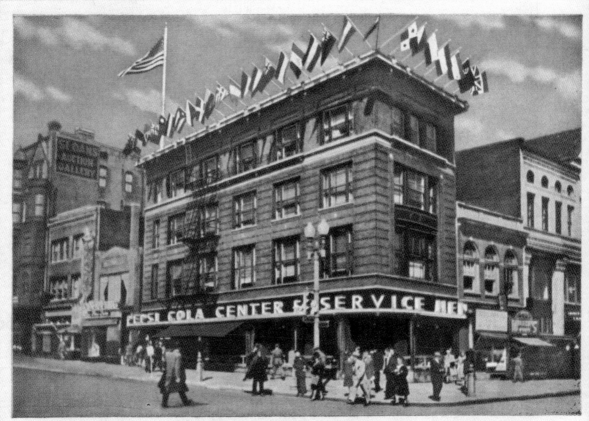

PEPSI-COLA CENTER FOR SERVICE MEN AND WOMEN, 13th AND G STS., N.W., WASHINGTON, D. C.

This 1940s real-photo postcard of the Pepsi-Cola Center for Servicemen proclaims the building as "center built and maintained by the Pepsi-Cola Company for the members of the Armed Forces of the United Nations in Co-operation with the Recreation Services, Inc. For the War Hospitality Committee of Washington, D.C."

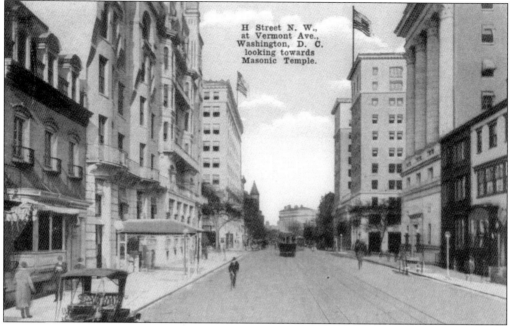

The reverse of this postcard states, "H St N.W. at Vermont Ave. looking towards Masonic Temple. To the right is seen the Shoreham Hotel and the Southern Office Bldg. to the left the Union Trust Co. and the Woodward Office Buildings."

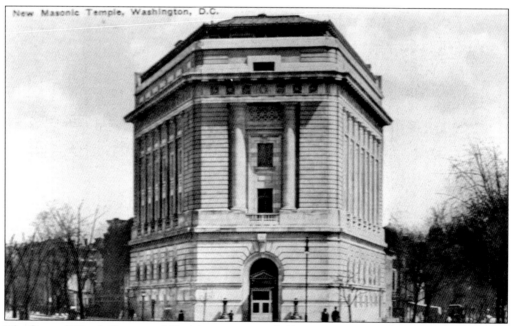

The firm of Wood, Dunn, and Deming constructed this Masonic Temple, located at New York Avenue and Thirteenth Street NW, in 1907–1908. Waddy B. Wood was the architect in charge. After various uses, including as a movie theater, Keyes, Condon, Florance architectural firm renovated this building in 1987 to become the National Museum of Women in the Arts, under the leadership of Wilhelmina Cole Holladay. (Linen Era.)

Four

SOUTHEAST AND SOUTHWEST AREA

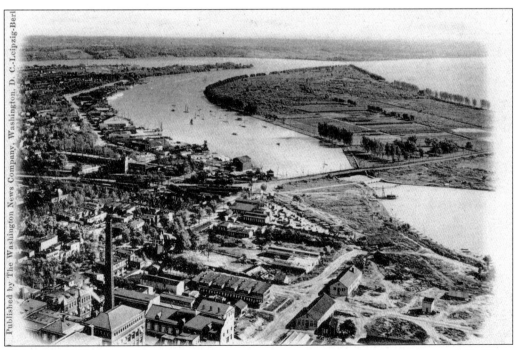

Published by The Washington News Company, Washington, D. C.-Leipzig-Berl

This early-1900s view of Southeast Washington shows the Navy Yard to the center left. There appears to be housing south of the Bureau of Engraving and Printing. The artificial peninsula of East Potomac Park, including Hains Point, which was named after supervising engineer Maj. Gen. Peter C. Hains, is beginning to show vegetation. Before electrical refrigeration, individuals used ice houses along the water's edge.

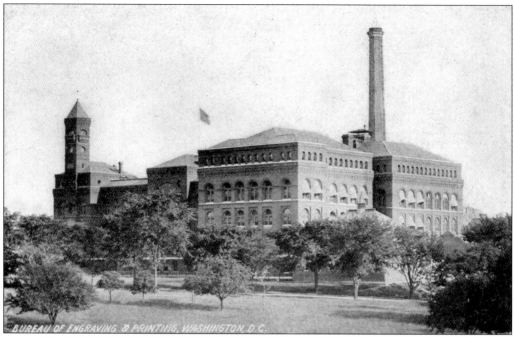

In 1880, James G. Hill built the Bureau of Engraving, which stands out because of its red brick exterior. This 1905 postcard highlights the building's chimney and clock tower. (Postcard Era.)

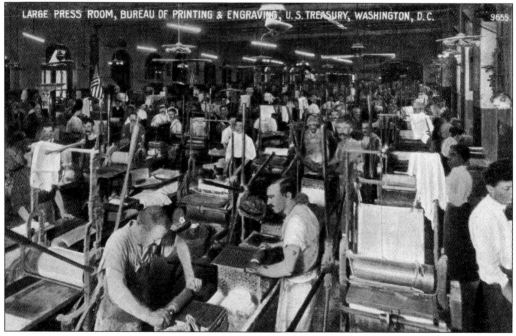

The Bureau of Printing and Engraving's large press room spotlights the equipment used for making paper money. The right side of the postcard shows women (perhaps cleaning up) while the rest of the workers are male. (Divided Back Era.)

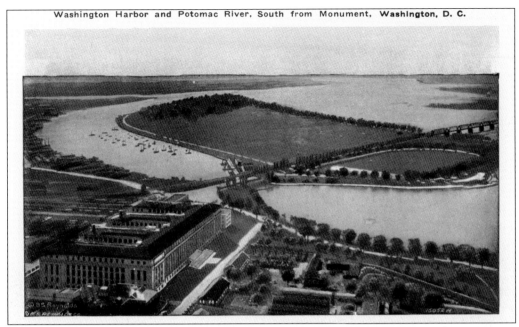

This postcard was printed after the new Bureau of Engraving and Printing opened in 1914. East Potomac Park was relatively barren at the time. The Tidal Basin area cherry trees (gifts from the people of Japan in 1912) are visible.

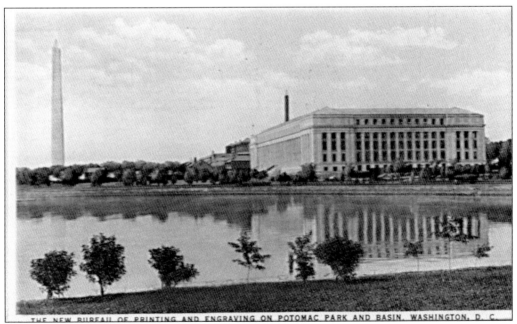

THE NEW BUREAU OF PRINTING AND ENGRAVING ON POTOMAC PARK AND BASIN, WASHINGTON, D. C.

Postmarked May 4, 1923, this postcard looks north from the Tidal Basin towards the Bureau of Printing and Engraving and the Washington Monument. The card's reverse states that the Bureau of Printing and Engraving cost $3.25 million to build. (White Border Era.)

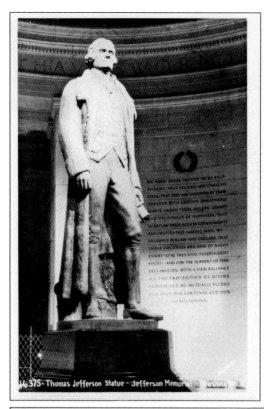

This real-photo postcard shows the Thomas Jefferson statue, rendered by Rudulph Evans and dedicated by Franklin Delano Roosevelt in 1943 on Jefferson's 200th birthday. Bronze was not readily available during World War II, thus the original statue displayed was the plaster model. Notice excerpts from the Declaration of Independence on the wall behind the statue.

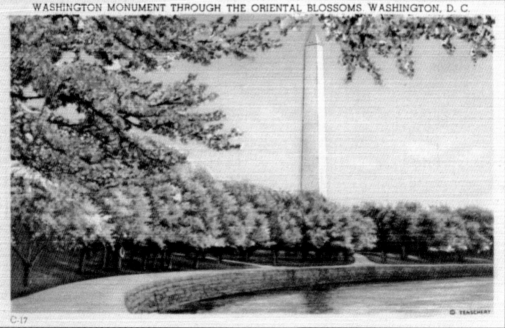

Printed during World War II (1939–1945), this postcard is not politically incorrect for the time. The cherry trees around the Tidal Basin, gifts from Japan, are called Oriental on the card. (Linen Era.)

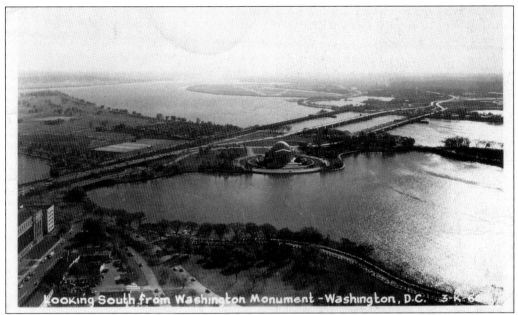

Looking South from Washington Monument - Washington, D.C. 3-K-5

This real-photo postcard shows the new Jefferson Memorial, designed by John Russell Pope. East Potomac Park includes some interesting buildings that may be part of the tourist camp shown in the postcard below.

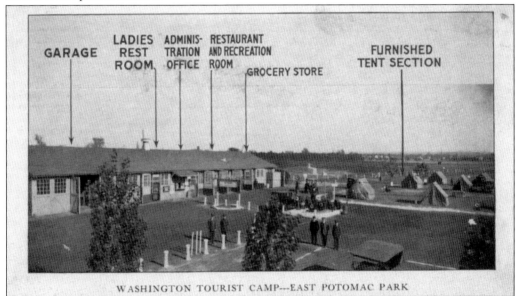

GARAGE | LADIES REST ROOM | ADMINISTRATION OFFICE | RESTAURANT AND RECREATION ROOM | GROCERY STORE | FURNISHED TENT SECTION

WASHINGTON TOURIST CAMP---EAST POTOMAC PARK

This real-photo postcard of the 1920s era shows the Washington Tourist Camp, which was "maintained for the welfare of automobile tourists, under the direction of the Officer in Charge of Public Buildings and Roads, District of Columbia, Washington, D.C. The camp is located on the beautiful Potomac River, near the center of national points of interest in the Nation's capital. Model camping facilities are provided for automobile tourists, including general store, restaurant, rest rooms, modern conveniences, tents with wooden floor, shower baths, electric lights, police protection, various forms of entertainment and recreation. Open the year round. Capacity unlimited."

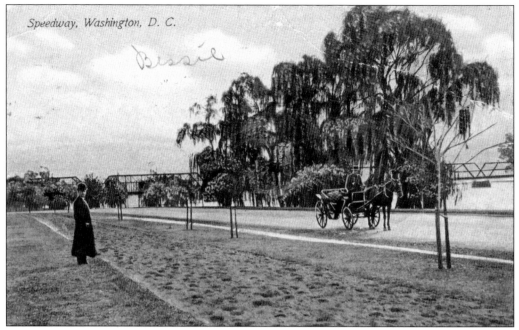

Speedway, Washington, D. C.

On the reverse of this postcard, postmarked 1914, the descriptive quote reads, "The Speedway. This Boulevard known as the 'Speedway' affords an excellent driveway along the picturesque Potomac. The roads are kept in fine condition by the government. Highway Bridge may also be seen."

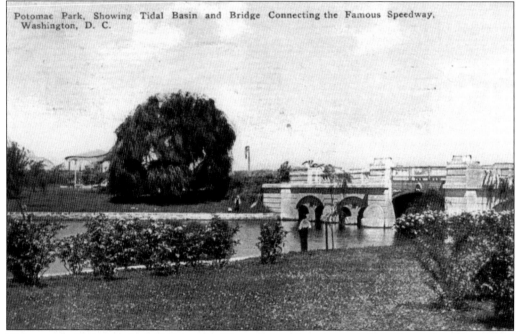

Potomac Park, Showing Tidal Basin and Bridge Connecting the Famous Speedway, Washington, D. C.

This postcard, postmarked 1913, reads, "Potomac Park is situated directly south of the White House and Washington Monument. It is one of the largest and most beautiful parks in America. Here can be seen the president and his official family daily, driving or taking an auto ride."

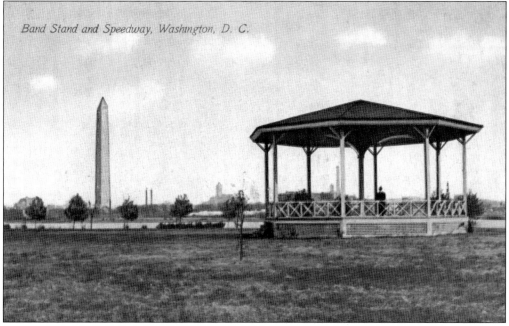

Band Stand and Speedway, Washington, D. C.

The back of this 1916-postmarked card reads, "Potomac Park Band Stand is located near Highway Bridge. Band concerts are held here during the summer. The Mt. Vernon R.R. cars pass near this stand."

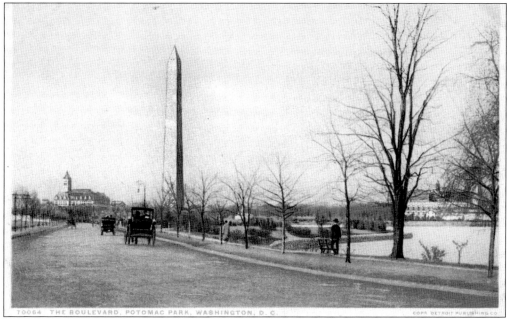

70064 THE BOULEVARD, POTOMAC PARK, WASHINGTON, D. C. COPR DETROIT PUBLISHING CO

This is another beautiful view of Potomac Park.

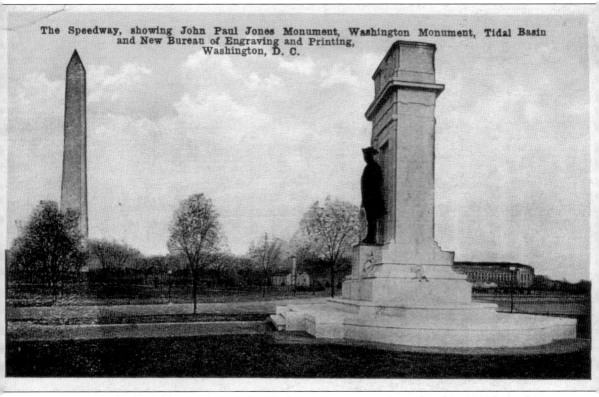

The Speedway, showing John Paul Jones Monument, Washington Monument, Tidal Basin and New Bureau of Engraving and Printing, Washington, D. C.

This postcard shows the Commo. John Paul Jones monument, completed in 1912 by architect Thomas Hastings and sculptor Charles Henry Niehaus. Born in Scotland in 1747, Jones joined the newly formed U.S. Navy in 1775. He had a distinguished naval career and is famous for the quote, "Surrender? I have not yet begun to fight." He died in 1792 and was buried in Paris, where his remains were discovered perfectly preserved in a barrel of rum in 1905. The remains were given to the Naval Academy in Annapolis with great fanfare. The following year, Congress appropriated $50,000 for this monument.

Five
NATIONAL MALL AREA

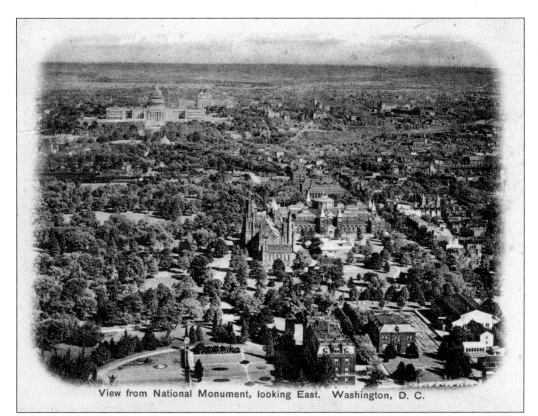

View from National Monument, looking East. Washington, D. C.

This early-1900s postcard shows the area from the Washington Monument to the Capitol before McMillan Commission planning changes took place. The original Agriculture Building is in the right front. The still-standing Smithsonian Castle and New National Museum are visible beyond. The Medical Museum and Library behind and to the right of the Smithsonian Castle have since been torn down. Notice a train is going across the Mall near Sixth Street.

This rare private mailing card includes a statue of Rear Admiral DuPont, which resided in Dupont Circle until 1920, when it was moved to Wilmington, Delaware. The Smithsonian Building, designed by architect James Renwick, was begun in 1849 and opened in 1856. An Englishman, James Smithson (who never set foot on American soil), bequeathed over $500,000 to Congress in 1846 for an "establishment for the increase and diffusion of knowledge." In 1904, Smithson's remains were transferred from Italy to a mortuary chapel just inside the entrance to the Smithsonian Castle on the Mall side. The building occupies the area formerly called B Street from Ninth to Twelfth Streets SW.

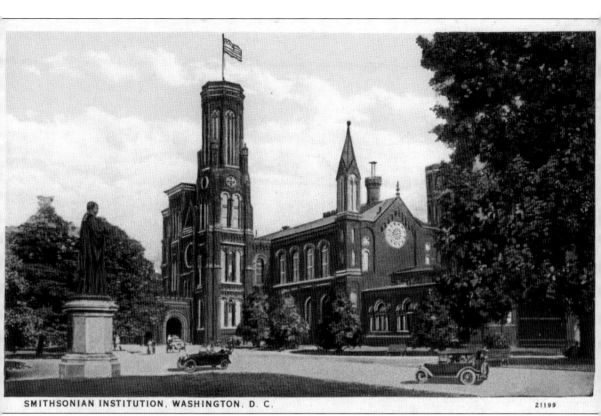

The Smithsonian's first secretary, renowned scientist Joseph Henry, resided with his family in the east wing of the castle for 29 years. His bronze statue, sculpted by William Wetmore Story, faces the building in this view. When the monument was dedicated in 1883, Story placed a relief of an electromagnet on the pedestal on which Henry leans. In 1965, the statue of Joseph Henry was turned to face the Mall, where so many of the Smithsonian Institution Buildings are now located.

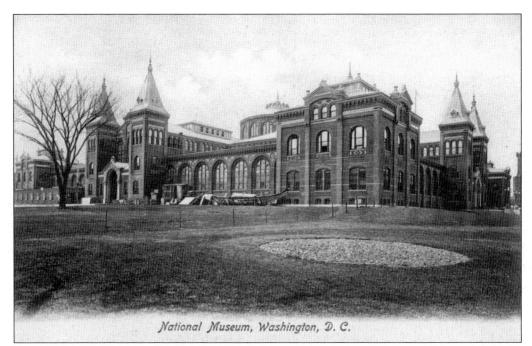

National Museum, Washington, D. C.

The National Museum was completed in 1880 as an annex to the Smithsonian Castle. Many artifacts from the Philadelphia Centennial Exposition were donated to the government, and a building was needed to house these gems. Adolph Cluss, in partnership with Paul Schulze, designed the building. It is now referred to as the Arts and Industries Building.

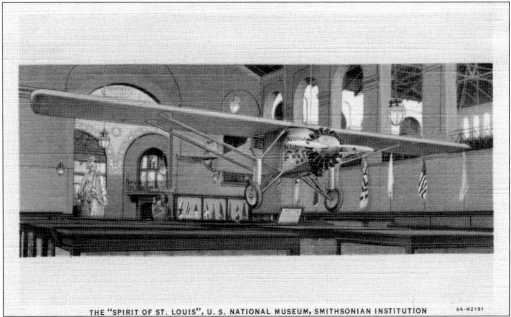

THE "SPIRIT OF ST. LOUIS", U. S. NATIONAL MUSEUM, SMITHSONIAN INSTITUTION 4A-H2191

This postcard highlights some of the artifacts on display in the National Museum Building. Hanging from the ceiling, over rows and rows of display cases, is Charles Lindbergh's *Spirit of St. Louis* airplane flown over the Atlantic Ocean in May 1927. Notice the model of the statue *Freedom* in the background. (Linen Era.)

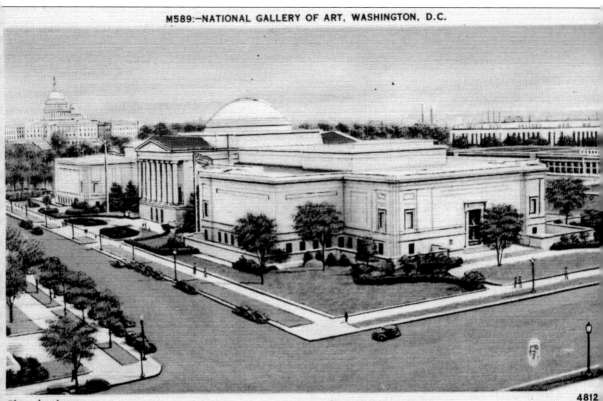

Photo by Acme

4812

John Russell Pope designed the National Gallery of Art Building on the north side of the Mall. The National Gallery was founded in 1937 and the building opened in 1941. Andrew Mellon donated an extensive collection of Old Master paintings to the gallery and also provided it with a hefty endowment. This postcard must have been issued prior to the opening because the caption on the reverse states, "It will contain the collections presented to the Nation by Andrew W. Mellon."

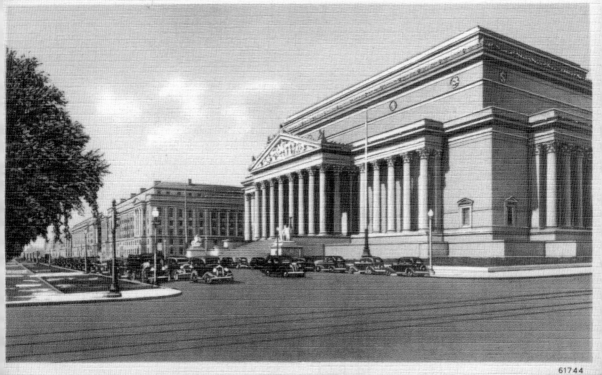

61744

Before the National Archives was established, historic documents were stored in a variety of places, including the attics and basements of the various government agencies' offices. Others were protected in the Library of Congress, the Smithsonian Institution, and the State Department, which, at times, put some on display. John Russell Pope designed the National Archives Building, which opened in 1935, where the public can view the original Declaration of Independence, the Constitution, and the Bill of Rights. The National Archives is the repository for the permanently valuable non-current records of the federal government. (Linen Era.)

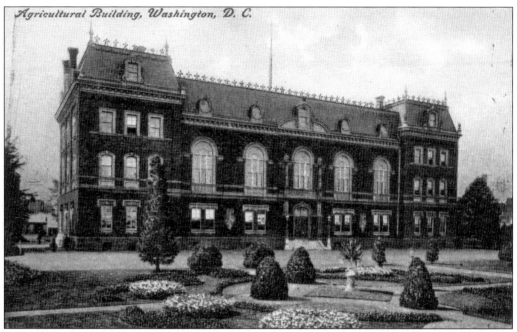

The Agricultural Building is on the site of property given to the Agriculture Department in 1862. The back of this early postcard proclaims, "This building is situated east of Washington's monument, and is surrounded by extremely beautiful lawns and gardens. Here tons of seed are given away annually to the farmers." This building was torn down in 1932.

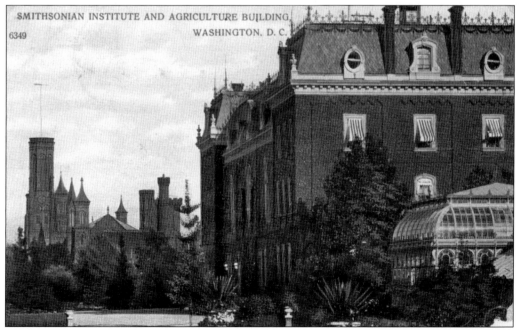

The Smithsonian Institute and Agricultural Building are shown in this unusual view that looks east on B Street SW. Included here is a neoclassical pavilion that was attached to the west side of the Agricultural Building.

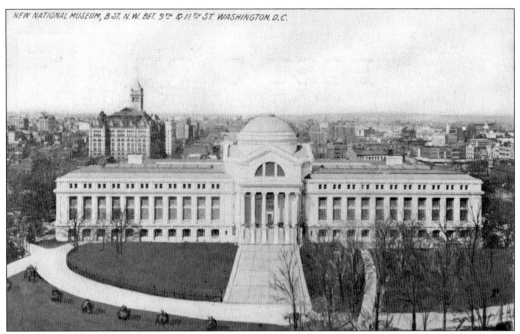

The "New National Museum" shown here is the present National Museum of Natural history. Located on the Mall, the firm of Hornblower and Marshall designed the building, which was completed in 1911.

The Washington Monument is the tallest masonry structure in the world. Designed by Robert Mills, the monument began construction in 1848 with donated funds. Unfortunately, funds ran out in the 1850s and construction halted. Finally, the U.S. Army Corps of Engineers took over the construction in the 1870s and completed the monument in 1884. The Washington Monument is 555 feet and 5-and-one-eighths-inches tall.

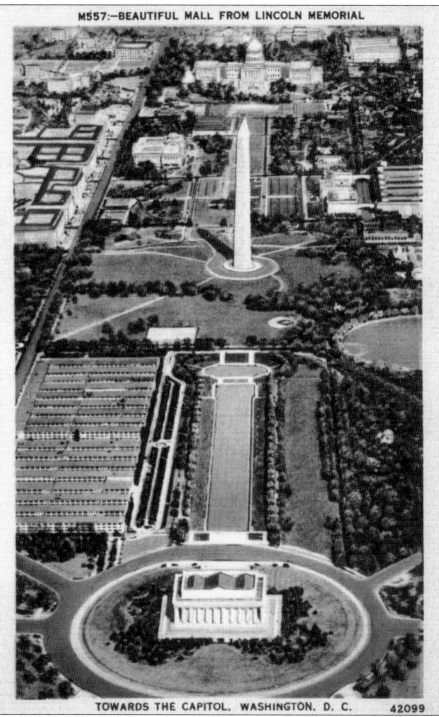

M557:—BEAUTIFUL MALL FROM LINCOLN MEMORIAL

TOWARDS THE CAPITOL, WASHINGTON, D. C. 42099

An aerial view of the glass-topped Lincoln Memorial shows the reflecting pool in the center and the "temporary" office buildings to the left (from the mid-20th century). Notice the District of Columbia World War I Memorial to the right. In the upper left, the Federal Triangle appears to the north of Constitution Avenue.

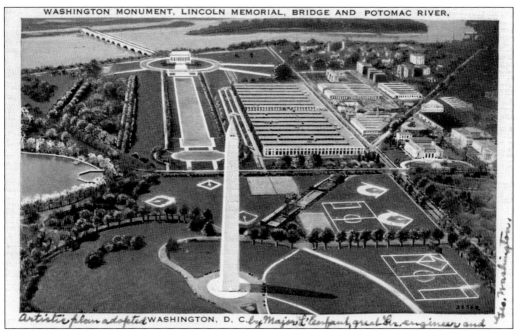

WASHINGTON MONUMENT, LINCOLN MEMORIAL, BRIDGE AND POTOMAC RIVER.

WASHINGTON, D. C.

This postcard notes: "Washington, D.C. viewed from a height of 5,000 feet in the air gives an idea of the artistic plan and treatment adopted by Major L'Enfant, the great French engineer, and George Washington, in making the Capital of the Nation the most beautiful city in the world." It shows the National Mall and the area north and west.

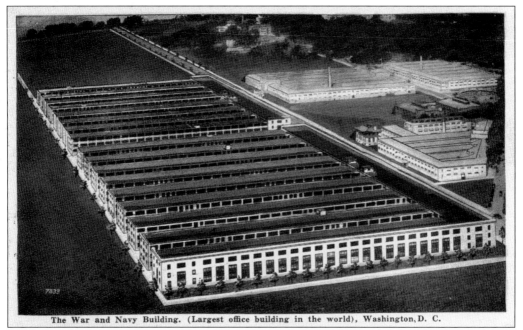

The War and Navy Building. (Largest office building in the world), Washington, D. C.

The reverse of this postcard states, "The view of the War and Navy Building, in Potomac Park, was taken from the top of the Washington Monument and gives one an idea how immense this new addition to the galaxy of new public buildings." To the north, in Georgetown, is the bridge spanning the Potomac River to Virginia. These buildings have all been torn down. (Linen Era.)

Six

VARIOUS BUILDINGS

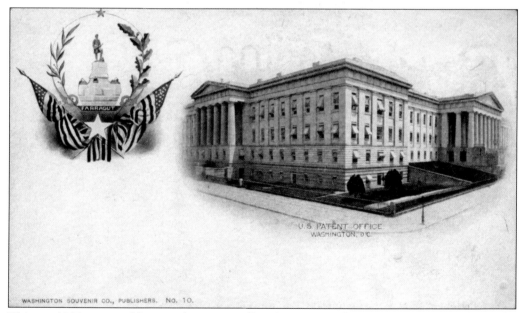

This pre-1900s postcard features the Patent Office, located at Eighth and F Streets NW. Architects A. J. Davis, Ithiel Town, and William P. Elliot were responsible for the 1836 building. Architects Robert Mills, Edward Clark, and Thomas U. Walter designed additions to the building. The Doric-columned portico is alleged to be an exact copy of the Parthenon's. This photograph was taken before the front steps were removed in the 1930s to make way for a wider street. The statue of Adm. David G. Farragut is located at Farragut Square, K Street, between Sixteenth and Seventh Streets NW. Sculptress Vinnie Ream Hoxie rendered this bronze statue in 1881. In 1864, during the Civil War, Farragut bravely led his fleet into minefields guarding Mobile Bay, where he uttered the memorable words, "Damn the torpedoes! Full Speed ahead!"

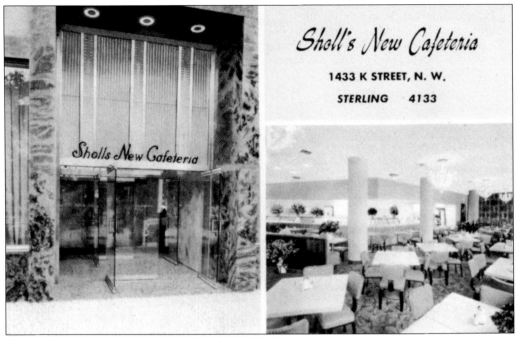

Located at 1411 K Street, Sholl's Cafeteria was a haven for tourists and locals alike. Its reasonably priced, nutritious meals provided sustenance for the crowds. On the postcard's reverse, the motto reads, "Live well for less money." (Linen Era.)

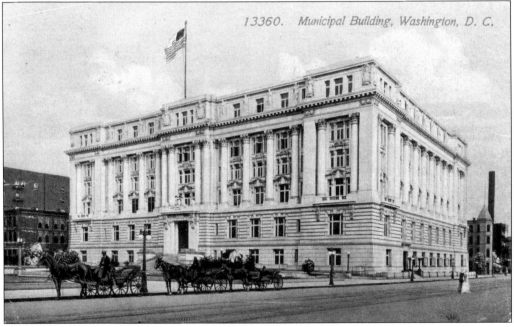

The reverse of this postcard, postmarked April 7, 1914, states, "Located on the south side of Pennsylvania Avenue between Thirteenth and Fourteenth Streets is the official home of the District of Columbia government."

In 1906, architect B. Stanley Simmons designed the Elks' Club at 919 H Street NW. The first Elks' Club is Washington, D.C., was organized in 1882. This building was razed in 1982..

Elks' Club, Washington, D. C.

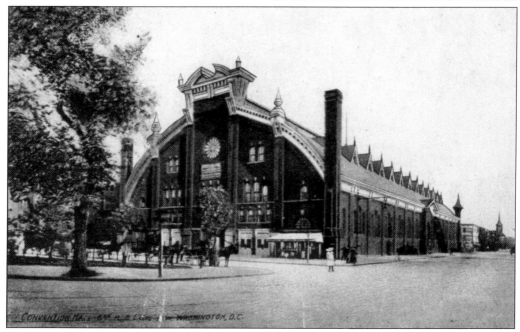

The Convention Hall was located at Fifth Street between K and L Streets NW. The original building had a steel-framed, 324-foot arched roof. An addition of a second floor in 1891 included a 5,000-seat auditorium. The building has since been torn down.

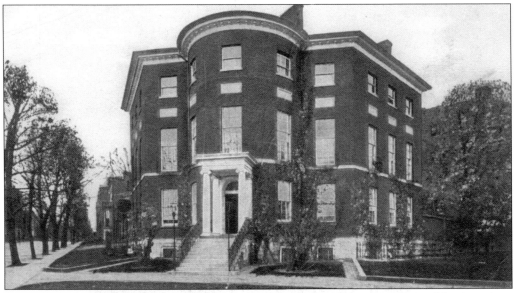

This view of the Octagon House was taken when it was the permanent office of the American Institute of Architects. The postcard's reverse explains, "The Octagon House at the corner of 18th Street and New York Avenue, (NW) Washington, D.C. is famous as the temporary White House. It was occupied by President James Madison after the British burned the White House in 1814, and the Treaty of Ghent which closed our second war with England, was signed within it. It was built in 1798 by Col. John Tayloe among whose most frequent guests was George Washington. The interior is elaborately finished. The original mantels, windows, and doors are in an excellent state of preservation, and two old cast iron wood stoves still stand in the niches prepared for them in the vestibule." (Linen Era.)

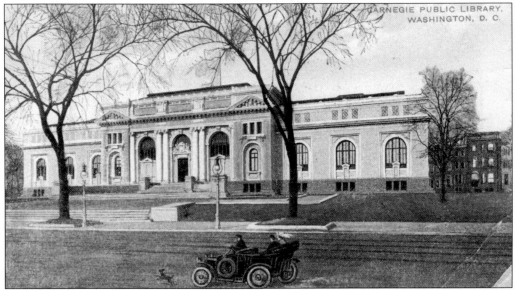

Located on Mount Vernon Square at Eighth and K Streets NW, Carnegie Library was completed in 1902 with funds provided by Andrew Carnegie. The architects Ackerman and Ross chose this Beaux-Arts style, which was popular at the time. This was the main library for the city from 1902 until the early 1970s.

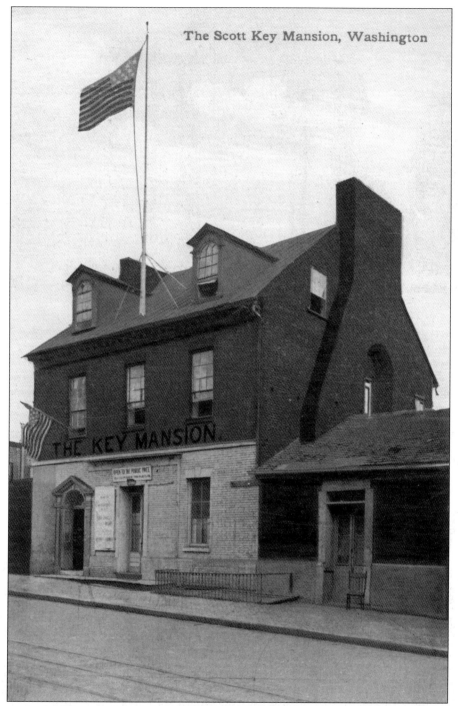

The Scott Key Mansion, Washington

THE KEY MANSION

The reverse of this postcard states, "The Key Mansion, home of Francis Scott Key, author of the 'Star Spangled Banner,' is located at 3518 M St NW. The one story annex at the right was his law office." Key resided in this house from 1805 until 1830. In the late 1940s, the house was removed to make way for a Whitehurst Freeway ramp leading to the Francis Scott Key Bridge. (Linen Era.)

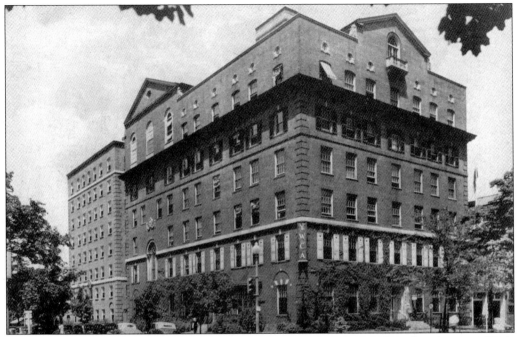

The Young Women's Christian Association Building at Seventeenth and K Streets NW is featured on this real-photo postcard. The reverse reads, "General Administration Building, 17th and K Sts., NW and Strong Residence 1011 17th St NW, which houses 190 transient and permanent guests."

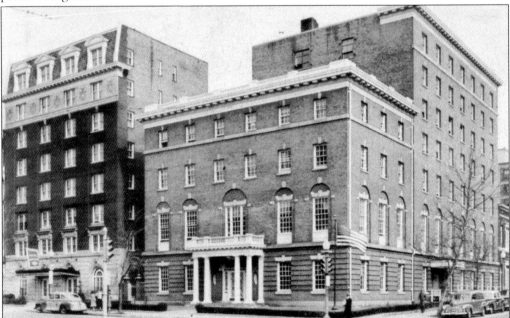

The National Education Association Building, located at 1201 Sixteenth Street NW and pictured in this real-photo postcard, "is staff headquarters building for [an] organization of educators which was founded in 1857 and chartered by Congress in 1906." This building has been replaced by a more modern structure.

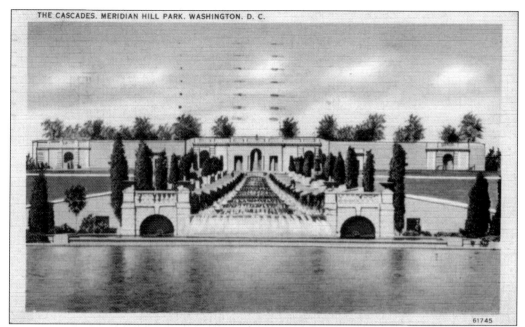

This view shows the Cascades at Meridian Hill Park, located at Sixteenth Street between Euclid and Florida Avenues NW. Horace Peaslee and landscape architect George Burnap designed the park in 1920. (Linen Era.)

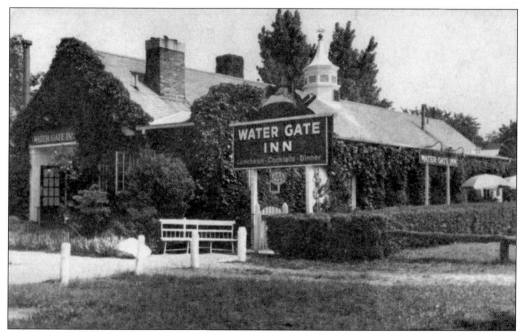

The Water Gate Inn on the Potomac at F Street SW was a "Pennsylvania Dutch restaurant famous for hot popovers, rare roast beef, seafood, Mennonite chicken [and] Dutch apple cheese pie." Its owner, Marjory Hendricks, prided herself on having the inn open every day all year from 11:30 a.m. to 10:00 p.m.

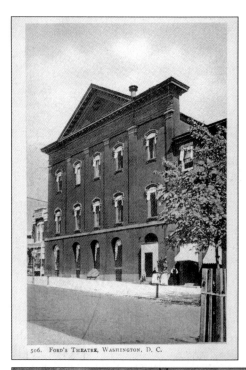

506. FORD'S THEATRE, WASHINGTON, D. C.

This postal card, authorized by an act of Congress on May 19, 1898, is the oldest postcard view the authors can find of Ford's Theatre. On Good Friday, April 14, 1865, John Wilkes Booth shot Pres. Abraham Lincoln while attending a play at Ford's Theatre. John Ford opened this theater in 1863. President Lincoln had attended performances several times previously, including a play in which John Wilkes Booth was one of the leading actors.

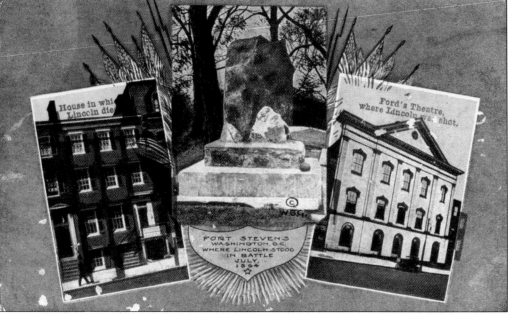

The reverse side of this postcard reads, "Fort Stevens, Washington, D.C. where Lincoln stood in battle is located off the main road between the National Soldiers' Home and Tacoma Park, D.C. a Memorial Boulder marks the spot. Ford's Theatre, wherein occurred the assassination of Lincoln, April 14, 1865, is on 10th Street between E and F Sts. NW. It is now used by the War Department as a branch of the Adjutant-General's Office. The house in which Lincoln died after being shot in Ford's Theatre on the opposite side of the street is located at 516 10th Street NW and contains the Oldroyd collection of relics and objects relating to Lincoln."

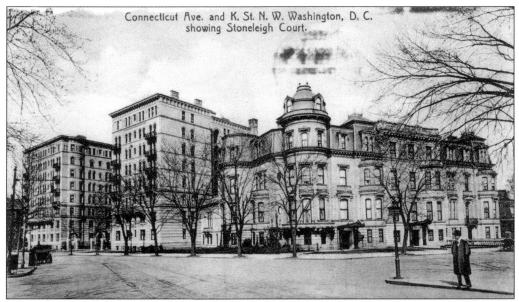

Connecticut Ave. and K. St. N. W. Washington, D. C.
showing Stoneleigh Court.

The apartments shown here on Connecticut Avenue NW demonstrate their accessibility both
by their "proximity to the downtown area" and by the public transportation in the form of the
streetcar that is pictured. Both of these views are from the early 1900s. Architect James G. Hill
designed Stoneleigh Court Apartment Building (above) in 1902. Jarrett White remodeled the
building in 1934. The building was razed in 1965.

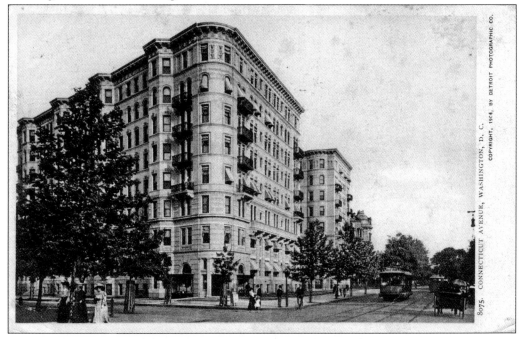

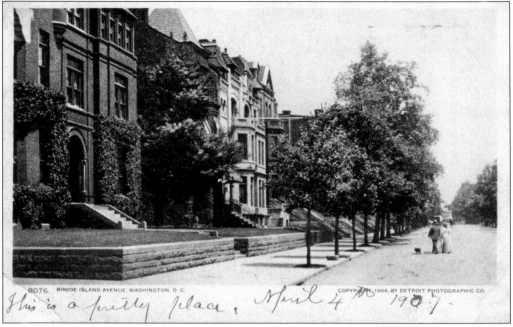

This 1907-postmarked card gives no information as to where on Rhode Island Avenue this property is located. (Postcard Era.)

The reverse of this postcard states, "National headquarters, National Society United States Daughters of 1812, 1461 Rhode Island Avenue, NW, Washington, D.C. 20005. A Society founded for Patriotic and Education Purposes in 1892 by Mrs. Flora Adams Darling." (Linen Era.)

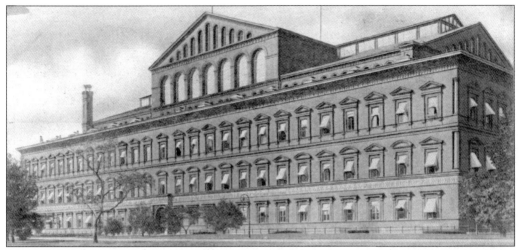

This early postcard shows the Pension Building *c.* 1900. Located between Fourth and Fifth Streets and F and G Streets Northwest, the building's architect was quartermaster general of the Union Army Montgomery Meigs. It was built between 1883 and 1887 to provide for the distribution of pensions to Union war veterans and their relatives. Nearly 15 million bricks were used in its construction. The Pension Building was known for its fireproofing, ventilation, and skylight. A 3-foot-tall, 1,200-foot-long, three-dimensional frieze sculpted by Casper Buberl runs between the first and second stories. It depicts Union soldiers and sailors. It is now the National Building Museum. (Postcard Era.)

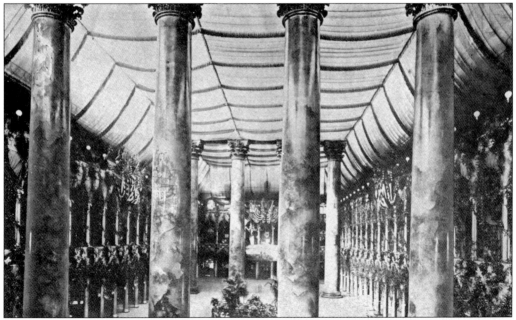

Montgomery Meigs designed a unique room as the centerpiece to the interior of the Pension Building. Its open space is 159 feet high, 316 feet long, and 116 feet wide. The entire room is surrounded by arcaded passages. Massive, 75-foot-high Corinthian columns support this office space and cast-iron roof. Each column consists of 70,000 bricks, plastered and faux-painted to give the appearance of marble. This early postcard shows the room decorated for one of many inaugural balls held there.

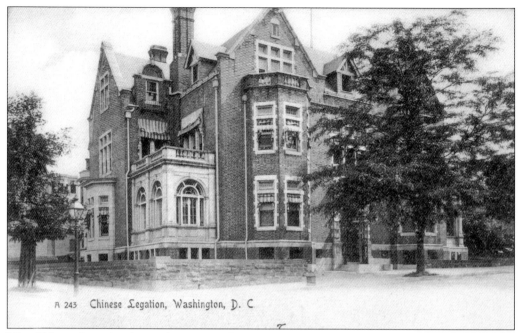

A 243 Chinese Legation, Washington, D. C

The Chinese Legation located on Massachusetts Avenue NW was designed by Nathan Wyeth in 1909. Until the mid-20th century, the term "embassy" was generally used when the diplomat was a representative of a monarch; republican countries used the title of legation.

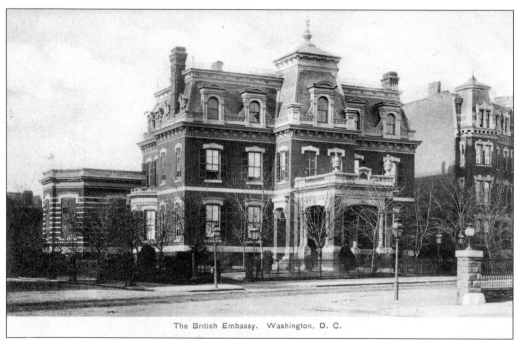

The British Embassy. Washington, D. C.

Located at Connecticut Avenue and N Street NW, the British Embassy was built in 1872 and designed by architect John Fraser. The building was razed in 1931.

Seven

SPECIAL EVENTS AND SIGHTSEEING

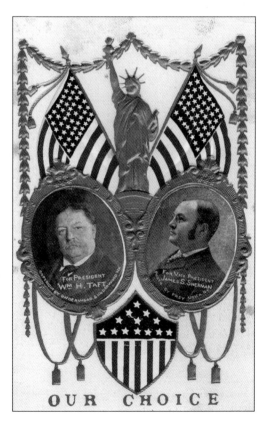

This campaign card combines several outstanding qualities of early postcards. The photos of the presidential and vice presidential candidates are set into an embossed surrounding. Notice the 46-star flags (New Mexico and Arizona had not joined the Union yet). The 15-star crest was typically used to denote the 15 states that were in the Union when the Federal City was opened in 1800. Pres. William Howard Taft (left) and Vice Pres. James Schoolcraft Sherman served from 1909 until 1913.

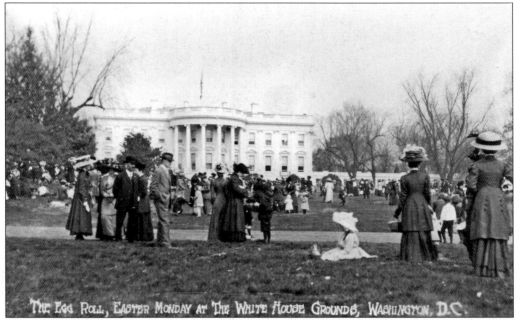

THE EGG ROLL, EASTER MONDAY AT THE WHITE HOUSE GROUNDS, WASHINGTON, D.C.

These two real-photo postcards depict a special event that is traditional to the White House's South Lawn. Every Monday after Easter Sunday, the White House hosts an Easter Egg Roll. These photographs were taken by Frederick A. Schutz of 1238 13 Street NW. Hand-written in pencil under the printed information are the words, "official White House photographer." President Truman later added the balcony to the south front of the White House.

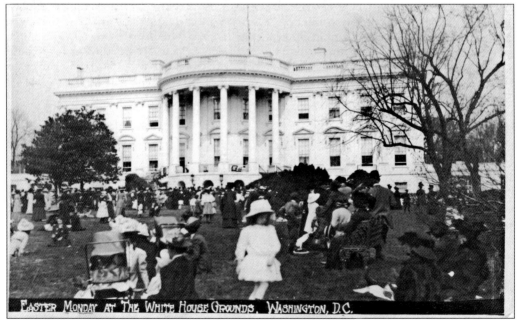

EASTER MONDAY AT THE WHITE HOUSE GROUNDS, WASHINGTON, D.C.

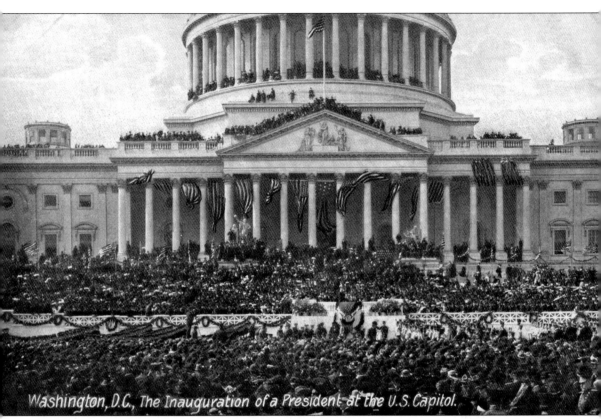

Washington, D.C., The Inauguration of a President at the U.S. Capitol.

The east front of the Capitol was traditionally where the president was inaugurated (until Ronald Reagan relocated it to the west front of the Capitol for more extensive viewing). This photo postcard gives us many clues to the era. People are posed on the balcony of the Capitol dome as well as on the balconies supported by the 16 Corinthian columns. The people standing over the Genius of America pediment of the east portico of the Capitol, sculpted by Luigi Persico, appear to be in a precarious stance.

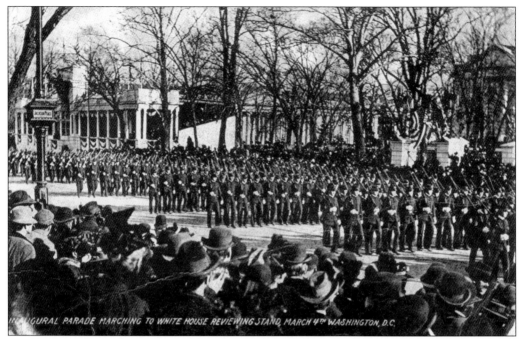

March 4 inaugurations occurred in 1897 and 1901 for Pres. William McKinley, 1905 for Pres. Theodore Roosevelt, 1909 for Pres. William Howard Taft, 1913 and 1917 for Pres. Woodrow Wilson, and 1921 for Pres. Warren Harding. It is impossible to determine which inauguration is depicted on the postcard above. Gen. James Franklin Bell, who was chief of staff of the U.S. Army from 1906 to 1910, is pictured in the postcard below, so most likely, the inauguration depicted there is in 1909 for Pres. William Howard Taft.

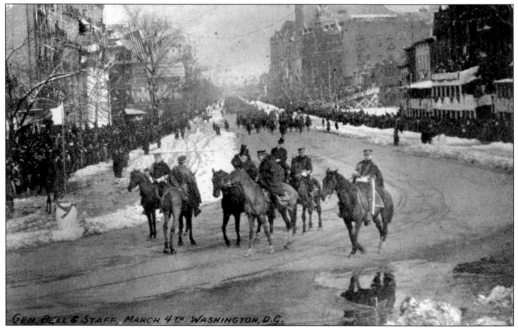

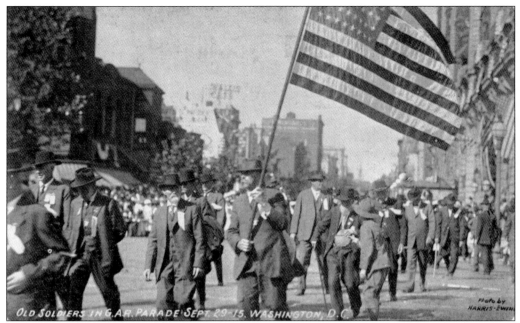

The GAR, Grand Army of the Republic, was a veterans' organization for Civil War Union soldiers and sailors.

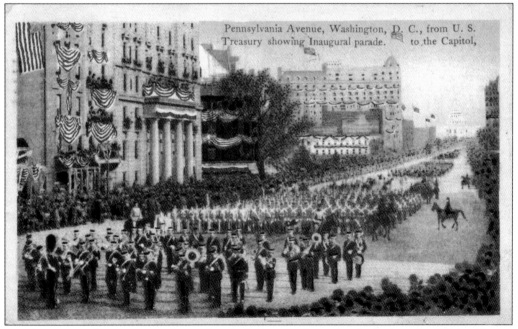

On this postcard, an inaugural parade winds its way from the Capitol to the White House. Unfortunately, the date of this inauguration is indiscernible. (White Border Era.)

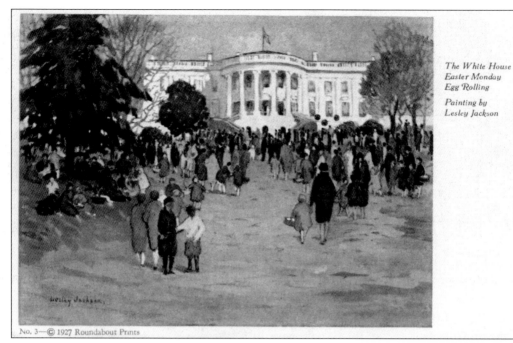

The White House
Easter Monday
Egg Rolling

Painting by
Lesley Jackson

No. 3—© 1927 Roundabout Prints

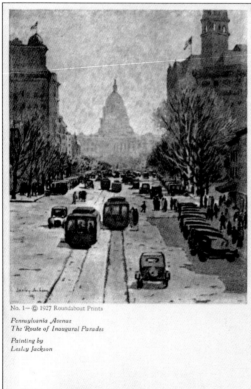

No. 1—© 1927 Roundabout Prints

Pennsylvania Avenue
The Route of Inaugural Parades

Painting by
Lesley Jackson

These two painting-reproduction postcards are part of a series issued in 1927 by Roundabout Press. Artist Lesley Jackson (1866–1958) painted them. (Divided Back Era.)

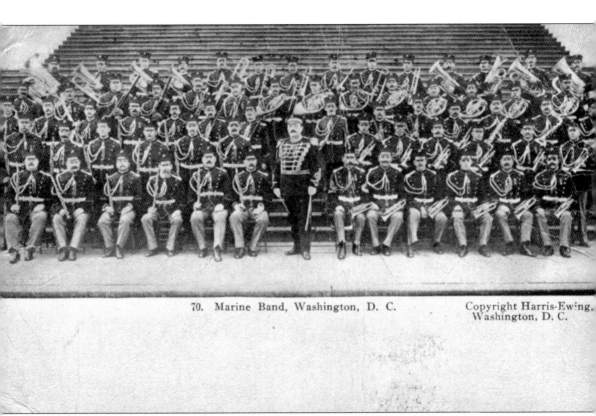

70. Marine Band, Washington, D. C.

Copyright Harris-Ewing, Washington, D. C.

This U.S. Marine Corps Band postcard is postmarked 1910. William H. Santelmann was the band director from March 3, 1898, until May 1, 1927. He started the tradition of keeping a daily log of the band's activities in 1916, and it continues today. John Phillip Sousa, a former director, auditioned Santelmann to be in the band.

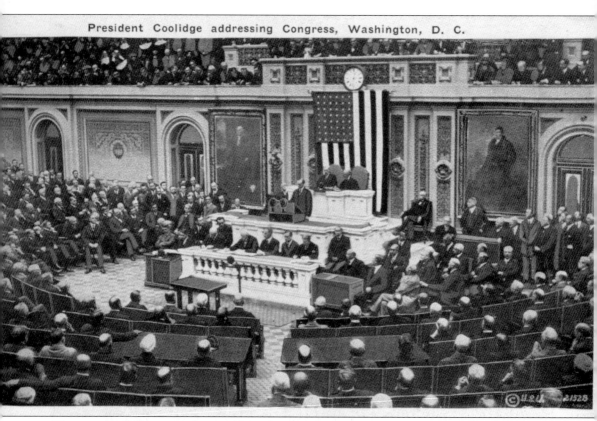

President Coolidge addressing Congress, Washington, D. C.

The reverse of this postcard states, "President Coolidge addressing Congress, Washington, D.C. The Hall of Representatives is a legislative chamber unsurpassed in the world. The dimensions are 139 by 93 feet. The speakers desk, of chiselled [*sic*] white marble, occupies an elevated position in the center of the south side and the seats of the representatives are arranged in concentric semi-circle, with radiating aisles. This picture shows the President delivering a message to Congress." (Divided Back Era.)

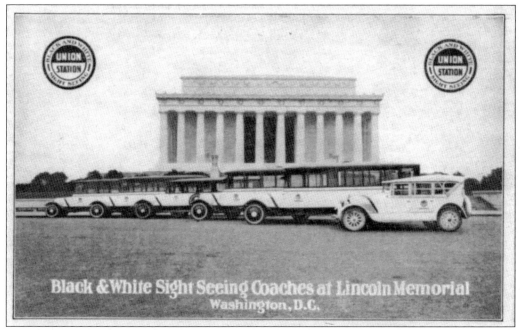

This advertising postcard spotlights the Black and White Sightseeing coaches.

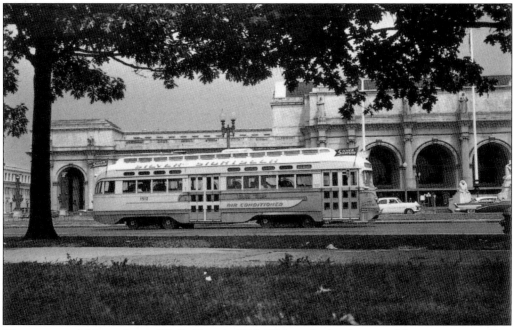

The reverse of this card says, "D.C. Transit 1512. This car had to be one of the most outstanding PCC cars in operation anywhere. Originally built by St. Louis Car Co, in 1945, the car saw several rebuildings and renumberings. In 1957 the car was revamped into a special car known as the 'Silver Sightseer' for touring our Nation's Capitol [*sic*]. It even boasted a lovely hostess to narrate the trip. 1512 is shown here passing Union Station, Washington, D.C. August 28, 1960." (Photograph by Norton D. Clark.)

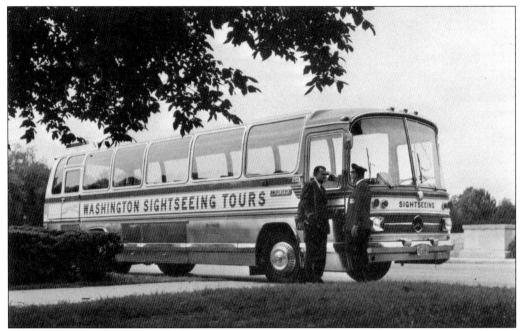

This is a Greyhound sightseeing bus. The postcard's reverse includes the caption: "Complete sightseeing tours of Washington, Arlington National Cemetery, Mt. Vernon, Alexandria and Georgetown. Featuring the new luxurious air-conditioned, carpeted Mercedez-Benz buses especially designed for sightseeing."

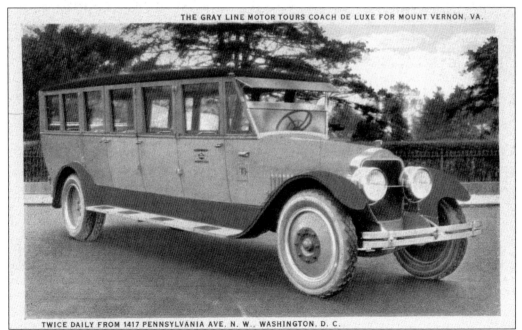

Gray Line has been providing tours of the area for some time. This "Gray Line Coach De Luxe" took tourists to Mount Vernon in Virginia.

Eight

CIRCLES, SQUARES, AND STATUES

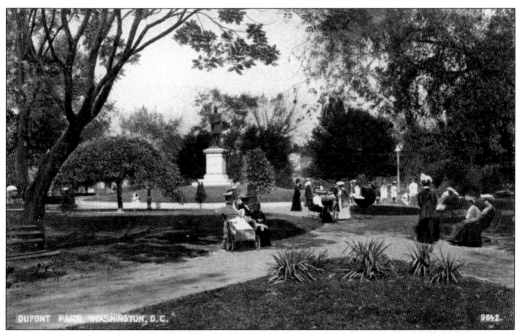

Dupont Circle is located at Massachusetts and Connecticut Avenues NW. This early-1900s postcard shows the civility of this lovely area. Western mining entrepreneurs transformed the area known as Pacific Circle into a fashionable residential neighborhood and renamed it in honor of Civil War rear admiral Samuel Francis DuPont in 1882. The statue was dedicated in 1884 but later removed by the DuPont family and placed in a Wilmington, Delaware, park.

A 207 a. Scotts Circle, Washington, D. C.

Thank you little girl; I will send you a card often. We are both well. have bought another house & live at 2035 H St. love to you all. aunt Nellie

Scott Circle is located at Massachusetts and Rhode Island Avenues and Sixteenth Street NW. The postcard has a 1905 copyright date. The Lt. Gen. Winfield Scott statue was dedicated in 1874. It is made of cannon captured by General Scott during the Mexican War, when he commanded the American army that captured Mexico City. Henry Kirke Brown, the sculptor of the statue, realized that General Scott's favorite mount was a small mare. Before Brown began sculpting the statue, some of Scott's descendants saw the model and protested. No general had ever been portrayed riding a mare. Brown then adapted the horse to have the face and neck of a stallion.

Sculpted by Gaetano Trentanove, this statue of Daniel Webster, dedicated in 1900, is located near Scott Circle. Webster was a great orator and statesmen who lived from 1782 until 1852.

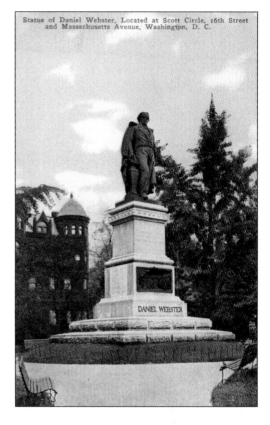

Statue of Daniel Webster, Located at Scott Circle, 16th Street and Massachusetts Avenue, Washington, D. C.

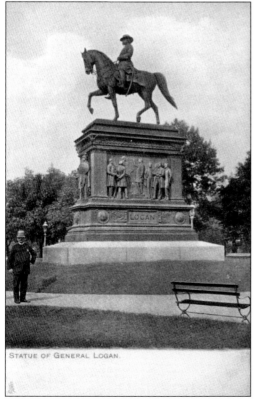

STATUE OF GENERAL LOGAN.

Maj. Gen. John A. Logan's statue, sculpted by Franklin Simmons, stands in Logan Circle on Vermont Avenue at Thirteenth and P Streets NW. It was dedicated on April 9, 1901. Logan commanded the Army of Tennessee during the Civil War and was a senator from Illinois. He lived at 812 Twelfth Street. This was called Iowa Circle until 1930. (Postcard Era.)

89

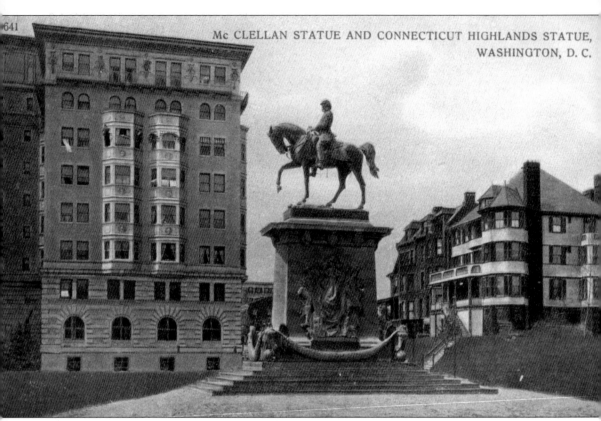

McCLELLAN STATUE AND CONNECTICUT HIGHLANDS STATUE,
WASHINGTON, D. C.

This statue of Maj. Gen. George B. McClellan, commanding general of the Union army during the Civil War, is located at the intersection of Connecticut Avenue and Columbia Road NW. In April and May 1902, a competition was held for a design of a McClellan statue. A board of judges, including sculptors Augustus Saint–Gaudens and Daniel Chester French and architect Charles F. McKim, reviewed 28 designs and, in 1903, awarded the contract to Frederick MacMonnies. The statue was dedicated in May 1907.

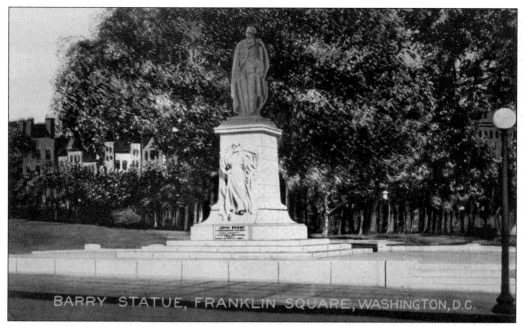

BARRY STATUE, FRANKLIN SQUARE, WASHINGTON, D.C.

The Commo. John Barry statue is located on the west side of Franklin Square. This postcard states, "Statue was erected by the United States Government at the request of Irish American groups at the cost of $50,000 and [was] dedicated May 16th, 1914." John Barry was the first captain and the first commodore of the U.S. Navy. The statue's sculptor was John J. Boyle and the architect was Edward P. Casey.

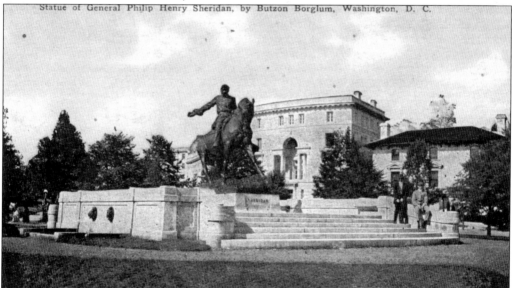

Statue of General Philip Henry Sheridan, by Butzon Borglum, Washington, D. C.

This early postcard captures the greatness of Gutzon Borglum's bronze sculpture of Lt. Gen. Philip H. Sheridan. The statue is located at Massachusetts Avenue and Twenty-third Street NW. Commander of the Union Army of the Shenandoah during the Civil War and later the commanding general of the U.S. Army, Sheridan is portrayed in a most dashing position astride his horse Rienzi. Pres. Theodore Roosevelt was present at the dedication of this statue on November 25, 1908.

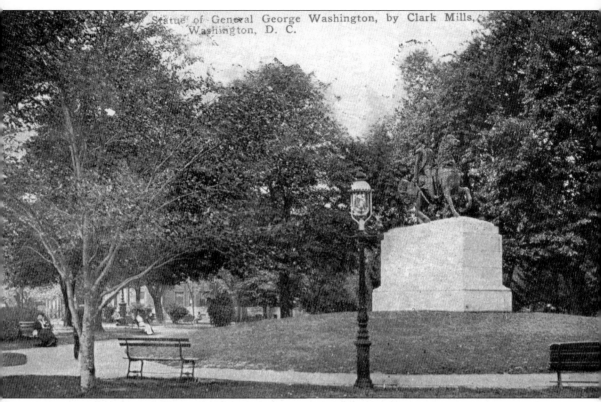

Statue of General George Washington, by Clark Mills,
Washington, D. C.

This early postcard shows the statue of George Washington, which is located on Washington Circle at Pennsylvania Avenue, intersected by Twenty-third and K Streets and New Hampshire Avenue NW. Sculptor Clark Mills depicts commander-in-chief of the Continental Army George Washington in bronze as he thinks he appeared at Princeton in December 1776 and Trenton in January 1777, when he led surprise attacks on the British. When this statue was unveiled in 1860, it received much criticism for the startled look of the horse and the calmness of Washington's face. George Washington was the first president of the United States (1789–1797).

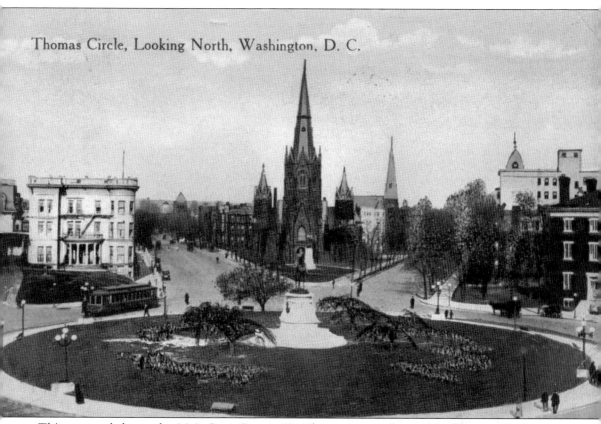

Thomas Circle, Looking North, Washington, D. C.

This postcard shows the Maj. Gen. George H. Thomas statue, located in Thomas Circle at Massachusetts Avenue and Fourteenth Street NW. John Quincy Adams Ward sculpted the statue, which was dedicated in 1879. Thomas, a Southerner from Virginia, remained in the U.S. Army when the Civil War began. At the Battle of Chickamauga, he made a gallant stand that saved the army and he was given the nickname "the Rock of Chickamauga." As a result, he was awarded with command of the Union Army of the Cumberland. Notice the beautiful Thomas Circle area and the cast-iron streetlights, c. 1880, that were removed in 1923.

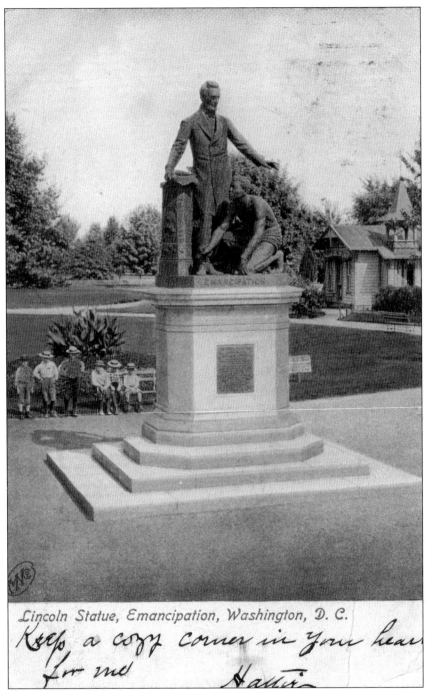

Lincoln Statue, Emancipation, Washington, D. C.

Keep a copy corner in your hear for me Hattie

The Emancipation Monument is located in Lincoln Park at East Capitol and Eleventh Streets NE. In this view, the statue is facing west (it now faces east, towards a statue of Mary McLeod Bethune). Maj. O. E. Babcock was the architect and Thomas Ball was the sculptor. The statue was dedicated on April 14, 1876. The Western Sanitary Commission of St. Louis raised $18,000 for the statue, including funds contributed by freed slaves. Abraham Lincoln was president from 1861 until 1865. (Postcard Era.)

Nine

BRIDGES

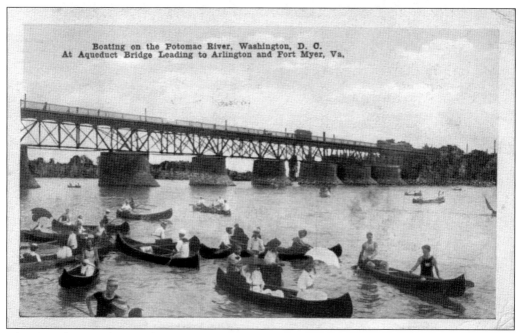

Boating on the Potomac River, Washington, D. C.
At Aqueduct Bridge Leading to Arlington and Fort Myer, Va.

The Aqueduct Bridge on the Potomac River appears on this postcard, postmarked 1912. The original aqueduct, constructed of wood, was completed in 1843 and transported canal boats from the Chesapeake & Ohio Canal across the Potomac River. During the Civil War, the army took over the aqueduct and converted it into a road. Following the war, it once again transported canal boats, and a roadbed was constructed above it. In 1885, the government purchased the bridge and replaced the wood with a metal truss bridge, shown here. Key Bridge replaced the Aqueduct Bridge in 1923.

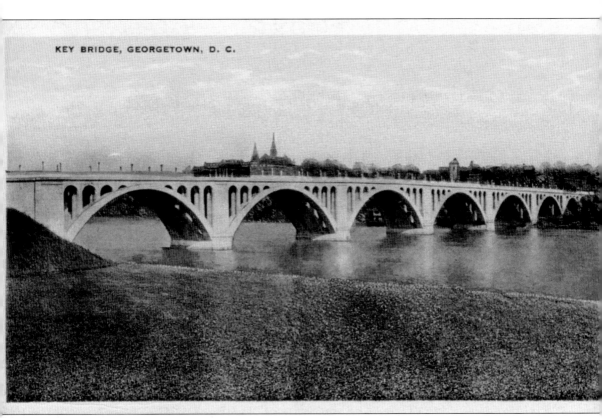

Key Bridge, named for Francis Scott Key, author of the "Star Spangled Banner," was completed in 1923. This bridge connects Rosslyn, Virginia, with Georgetown. The postcard's reverse proclaims, "This splendid concrete Bridge, the largest of its kind in the world, spanning the historic Potomac . . . connects the city of Washington with the State of Virginia." (White Border Era.)

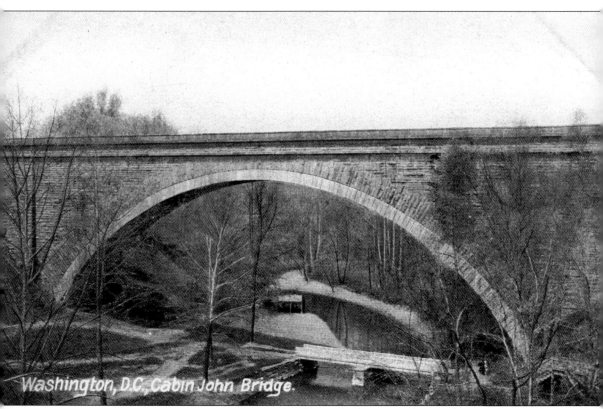

Washington, D.C., Cabin John Bridge.

Montgomery Meigs supervised the construction of Cabin John Bridge, which was built between 1857 and 1864. It was the largest masonry arch for 40 years. In 1867, Congress gave control of public parks and monuments to the Office of Parks, Buildings, and Grounds under the control of the chief of the Army Corps of Engineers. (Postcard Era.)

Rock Creek Park, Showing Piney Branch Bridge, Washington, D. C.

Piney Branch Bridge is in Rock Creek Park, near the Piney Branch quarry. The quarry drew much interest from scientists in the 1880s and 1890s as it yielded a great deal of evidence of past civilizations.

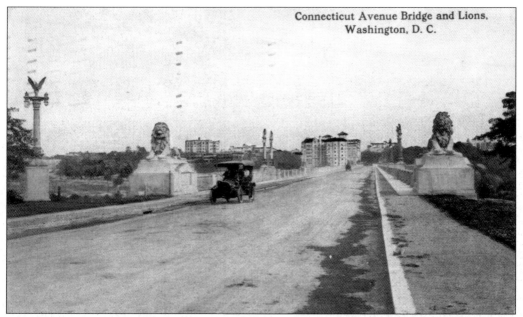

The Connecticut Avenue Bridge and lions (sculpted by R. Hinton Perry) appear on this 1913-postmarked postcard. The reverse reads, "Showing the massive lions at approach to Connecticut Avenue Bridge, leading to the [Zoo], [Rock Creek Park] and Washington's most fashionable suburbs."

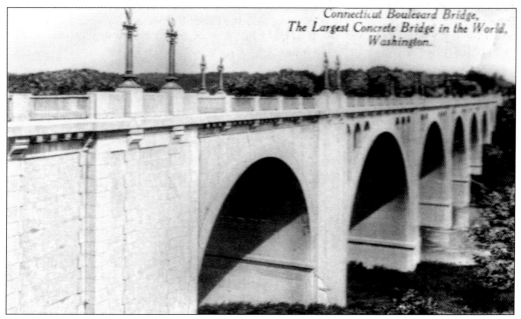

The reverse of this postcard reads, "Connecticut Boulevard Bridge. This massive work is one of the notable features of the recent development of Washington. It is the largest concrete bridge in the world." The bridge was built between 1897 and 1907. It was designed by George S. Morison, and Edward Casey was the supervising architect. The bridge spans Rock Creek Parkway as Connecticut Avenue passes over it.

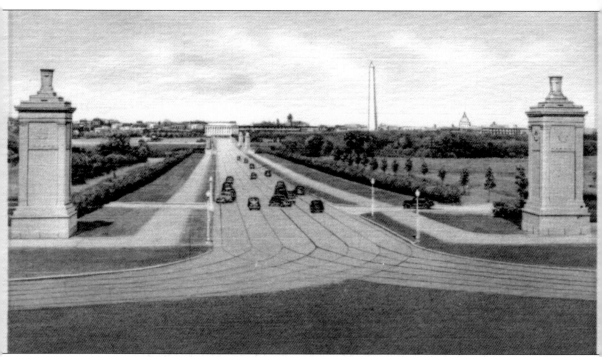

Although originally proposed in the mid–1800s, construction of the Arlington Memorial Bridge did not begin until 1926. Completed in 1932, the bridge provided a direct route between Arlington National Cemetery in Arlington, Virginia, and Washington. The architectural firm of McKim, Mead, and White designed the bridge, which is 2,138 feet long.

Ten

CHURCHES, HOTELS, AND INSTITUTIONS OF HIGHER LEARNING

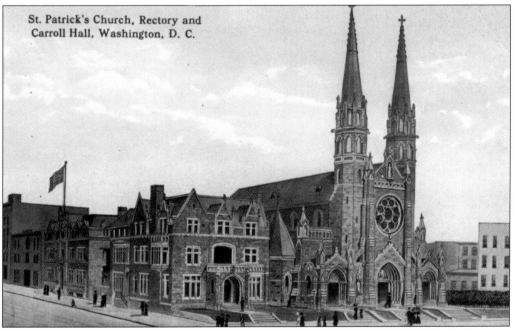

St. Patrick's Church, Rectory and Carroll Hall, Washington, D. C.

This very old postcard shows Saint Patrick's Church, Rectory, and Carroll Hall. Founded between 1789 and 1794 at 619 Tenth Street NW, Saint Patrick's was the only Catholic church in the city limits until 1820. The parish was formed to accommodate the religious needs of stonemasons who were working on the construction of the president's house and the Capitol. The structure depicted here was completed in 1884. (Postcard Era.)

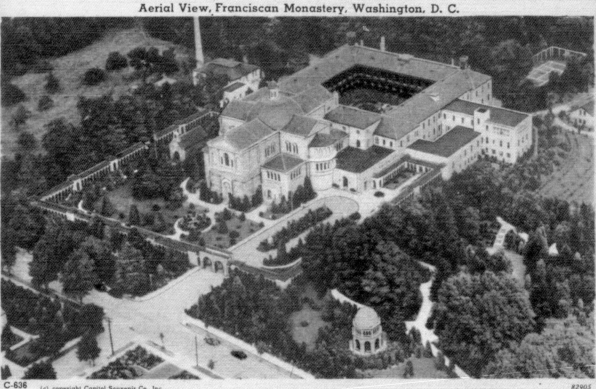

This is an aerial view of the Franciscan Monastery, located at 1400 Quincy Street NE. The reverse of the card reads, "Ground was broken for the Franciscan Monastery early in February 1898; the cornerstone was laid on March 19 of the same year, and on September 17, 1899, the Church and Monastery were dedicated." Fr. Godfrey Shilling enlisted the work of architect Aristides Leonori to create the "official Commissariat for the Holy Land of the United States."

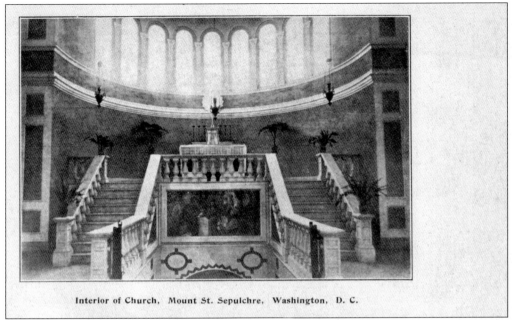

Interior of Church, Mount St. Sepulchre, Washington, D. C.

This postcard contains an interior view of the Mount St. Sepulchre. Built at a time when most Americans thought it impossible to go overseas, the monastery includes replicas of Holy Shrines in Israel, Egypt, Syria, and Jordan.

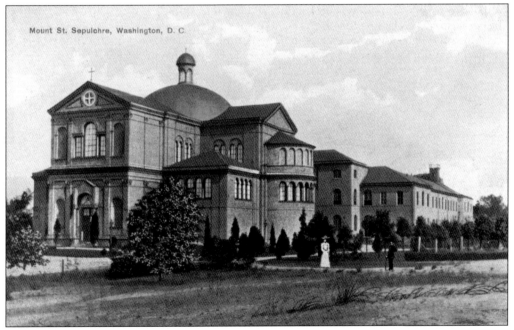

Mount St. Sepulchre, Washington, D. C.

Mount St. Sepulchre is the church at the Franciscan Monastery. Over 700 years ago, the Order of St. Francis was entrusted to oversee Christian shrines along with many other caregiving duties.

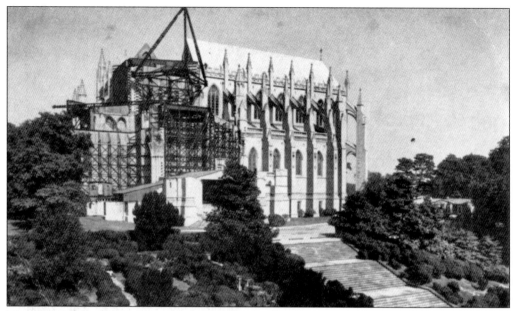

The Cathedral of St. Peter and St. Paul (the Washington National Cathedral) is located near the intersection of Wisconsin and Massachusetts Avenues NW. Ground was finally broken in 1907 for a "national" church, originally envisioned by Pierre L'Enfant, George Washington, and other early leaders. The issue of the separation of church and state delayed its inception. The architects who have worked on this Gothic-style edifice include George Bodley, Henry Vaughn, and Arthur B. Heaton. The church is not supported by any government funds; it welcomes all people and is supported by donations. It is under the care of the Protestant Episcopal Cathedral Foundation. The cathedral was declared finished in 1990.

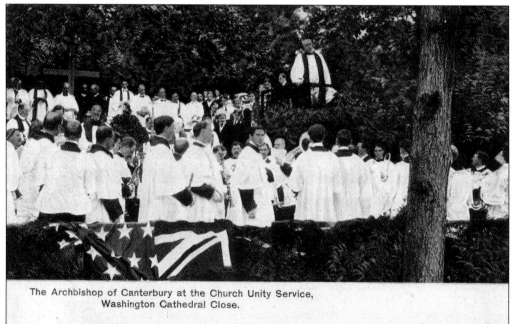

The Archbishop of Canterbury at the Church Unity Service, Washington Cathedral Close.

This early postcard depicts a ceremony that took place on the Cathedral Close. (Postcard Era.)

There was a First Presbyterian Church between C and D Street NW on the former Marshall Place. It was demolished in the 1930s..

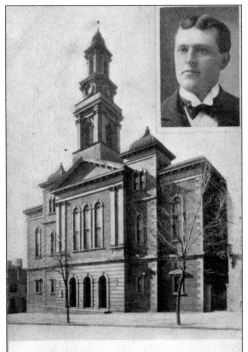

THE FIRST PRESBYTERIAN CHURCH, WASHINGTON, D. C.
ATTENDED BY PRESIDENTS POLK, PIERCE, CLEVELAND, AND GENERAL GRANT

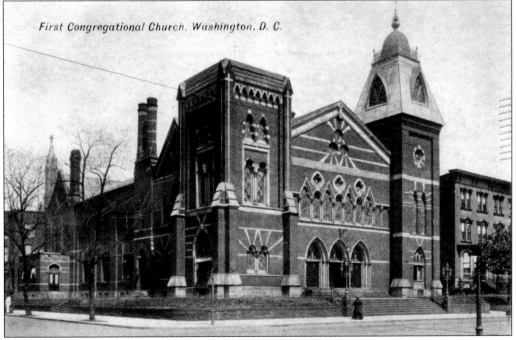

First Congregational Church, Washington, D. C.

The First Congregational Church of Washington, D.C., was located at Tenth and G Streets NW. Architect Henry R. Searle Jr. of Rochester, New York, oversaw the construction of this church starting in 1866. In 1920, Marian Anderson was introduced here in a concert. The structure was razed in 1959.

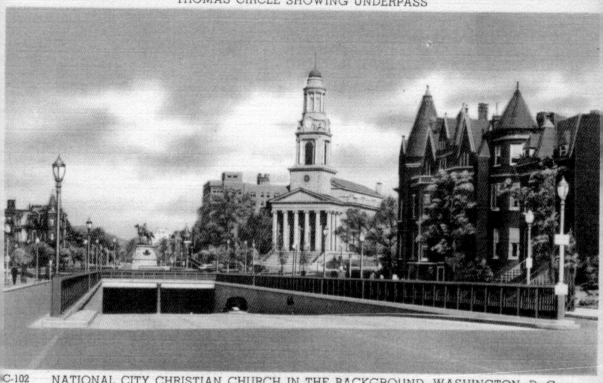

C-102 NATIONAL CITY CHRISTIAN CHURCH IN THE BACKGROUND, WASHINGTON, D. C.

John Russell Pope designed the National City Christian Church, located at Fourteenth Street and Massachusetts Avenue NW. It was dedicated in 1930. The reverse of the card states, "Thomas Circle. This shows Washington's first underpass and is located at Thomas Circle and 14th Street NW, and shows the statue of Gen. George H. Thomas as well as the National City Christian Church." (Linen Era.)

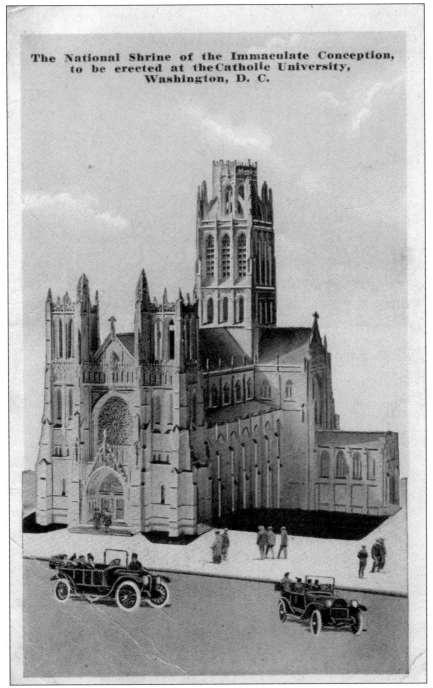

The National Shrine of the Immaculate Conception, to be erected at the Catholic University, Washington, D. C.

The reverse of this postcard reads, "The Shrine of the Immaculate Conception is a large and beautiful church in honor of Our Blessed Mother's most admirable title, to be built by a nation-wide co-operation, on the grounds of the Catholic University at Washington, at the heart of the nation, as a great thank-offering for countless benefits received and a Perpetual monument to the Immaculate Queen of Hearts, raised by her countless clients in the United States and elsewhere." (Linen Era.)

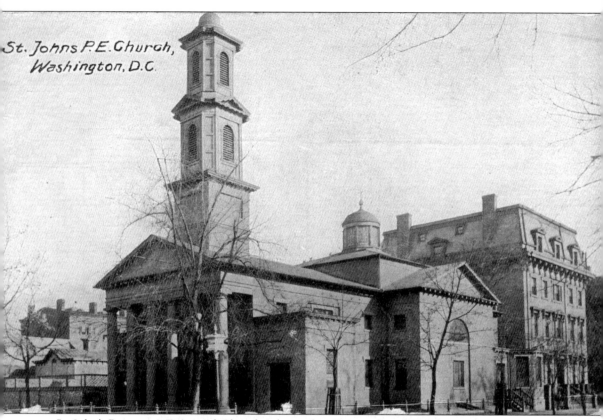

St. John's Protestant Episcopal Church is located at Sixteenth and H Streets NW. The original architect, in 1815, was Benjamin Latrobe. Architect James Renwick worked on the building from 1881 to 1890, and in 1919, the architectural firm of McKim, Mead, and White renovated it. Pew 54 is set aside for the chief executive and family. The building behind the church is St. John's Parish Building at 1525 H Street NW. It was started in 1836 by Matthew St. Clair Clark, who went bankrupt and sold it to the British government. In the parlor, Lord Alexander Ashburton and Daniel Webster negotiated the Webster-Ashburton Treaty, which settled the Maine and New Brunswick boundary.

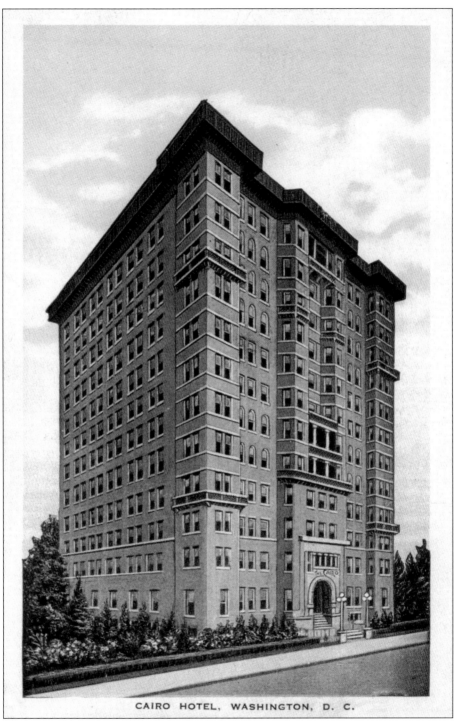

CAIRO HOTEL, WASHINGTON, D. C.

Thomas Franklin Schneider directed the building of the Cairo Hotel at Sixteenth and Q Streets NW in 1894. This steel-framed skyscraper exceeded the reach of fire equipment. The concern about safety was one of the reasons Congress passed the Height of Building Act of 1910. The reverse of this postcard says it is "away from noise and bustle, yet conveniently located." (Linen Era.)

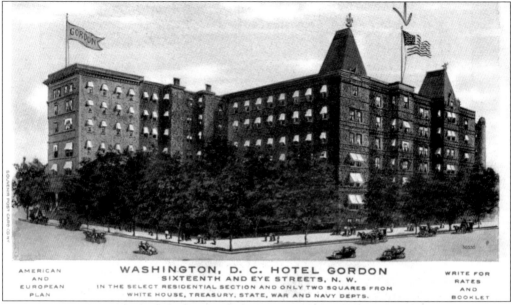

WASHINGTON, D. C. HOTEL GORDON
SIXTEENTH AND EYE STREETS, N. W.
IN THE SELECT RESIDENTIAL SECTION AND ONLY TWO SQUARES FROM
WHITE HOUSE, TREASURY, STATE, WAR AND NAVY DEPTS.

WRITE FOR
RATES
AND
BOOKLET

This postcard of the Hotel Gordon includes much information about the hotel. I Street was often spelled Eye so as not to be confused with First Street. The arrow toward the American flag on the rooftop was added by someone who possessed this postcard. The only additional information on the reverse of the card is "Hotel Gordon, Washington, D.C. T.A. Mckee, Prop." (White Border Era.)

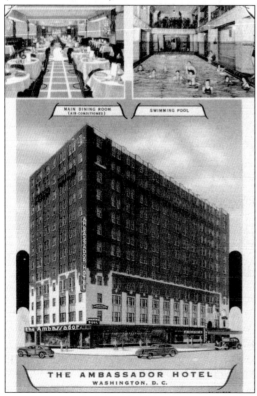

On the reverse of this card, the Ambassador Hotel boasts, "Washington's newest 500 room downtown hotel. Radio in every room. Swimming pool free to guests. Air Conditioned Dining Room and Cocktail Lounge. Rates from $2.00. You'll like the Ambassador." (White Border Era.)

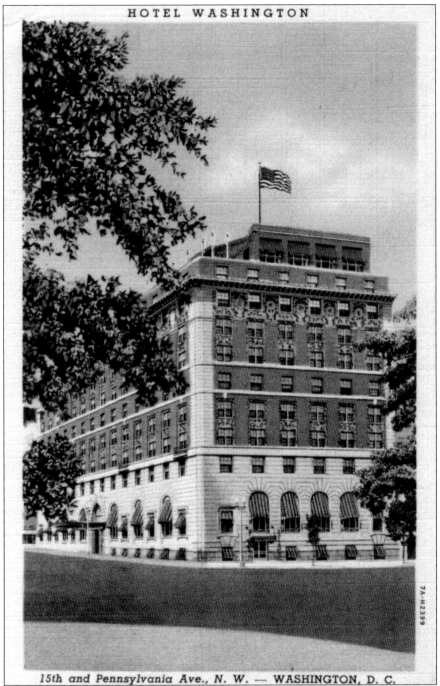

HOTEL WASHINGTON

15th and Pennsylvania Ave., N. W. — WASHINGTON, D. C.

This Hotel Washington postcard is postmarked 1947. Included with the postmark is the statement "1847 Centenary International Philatelic Exhibition." The hotel was completed in 1917. Thomas Hastings and John Carrere, the architects for the original House and Senate office buildings, were the architects. It claims to be the oldest continuously operating hotel in the city. The trompe l'oeil frieze portrays the presidents of the United States, appropriate as the inaugural parade passes by every four years.

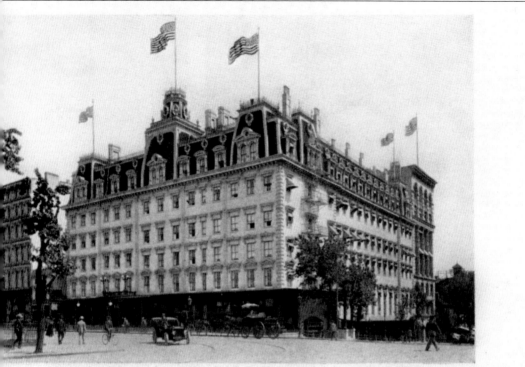

THE EBBITT HOUSE, ARMY AND NAVY HEADQUARTERS, WASHINGTON, D. C.

This private mailing card, authorized by Congress on May 19, 1898, shows the Ebbitt House. The Ebbitt House, located at F and Fourteenth Streets, was built in 1872, In 1895, an out-of-scale mansard roof was added. The structure was razed in 1926 for the National Press Building.

The new Ebbitt Hotel gives its location as Tenth and H Streets NW. The card's reverse states that the hotel has 150 rooms and baths and is "Midway between the White House and the Capitol, and in the center of the business and theatrical districts." In the records of the fraternity Delta Phi Epsilon, "smokers" (informal gatherings for men) were held at the new Ebbitt Hotel in 1920. (Linen Era.)

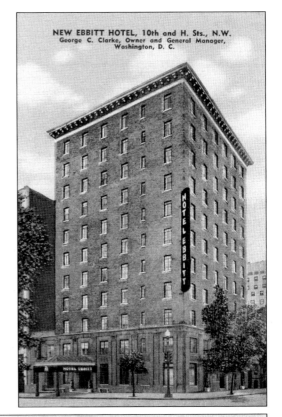

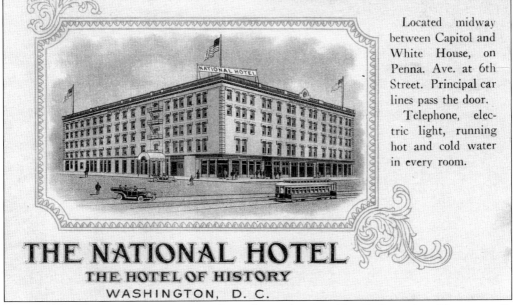

Located midway between Capitol and White House, on Penna. Ave. at 6th Street. Principal car lines pass the door.

Telephone, electric light, running hot and cold water in every room.

THE NATIONAL HOTEL
THE HOTEL OF HISTORY
WASHINGTON, D. C.

This advertising postcard for the National Hotel provides a wealth of information. The postcard's reverse lists the hotel's rates as "American Plan $2.50 to $4.00, European Plan $1.00 to $2.50." Notice how many American flags are displayed over the hotel. It was torn down in 1942. (Divided Back Era.)

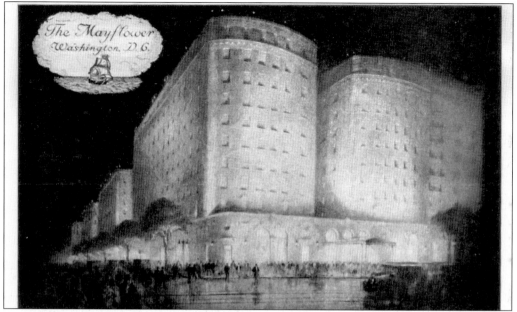

The grandeur of the Mayflower Hotel at 1127 Connecticut Avenue NW is quite evident in this postcard. Some people call it the second-best address in Washington (the best address being 1600 Pennsylvania Avenue). New York architects Warren and Westmore designed the hotel, which opened in 1925; they also designed New York's Grand Central Station. A one-tenth-of-a-mile promenade graces the center of the hotel on the main floor. (White Border Era.)

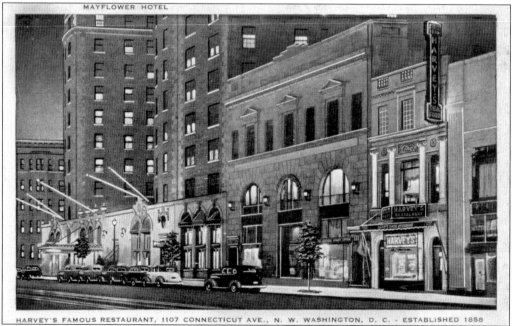

The reverse of this postcard states, "Harvey's Famous Restaurant is a point of interest in the Nation's Capital. For over eighty-five years world-famous celebrities have visited its dining rooms to partake of its inimitable and far renowned culinary accomplishments. No visit to Washington is complete without a meal at Harvey's." (White Border Era.)

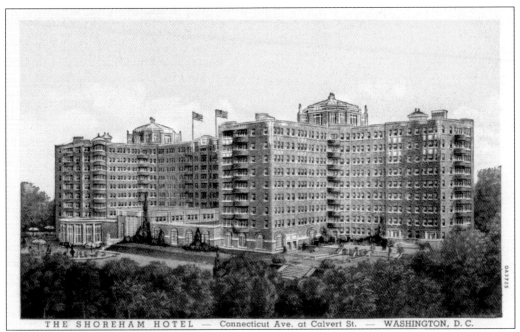

THE SHOREHAM HOTEL — Connecticut Ave. at Calvert St. — WASHINGTON, D. C.

The Shoreham Hotel touts itself as a "resort Hotel in the Nation's Capital, Connecticut Ave. at Calvert Street [NW]. Washington's newest hotel [is] situated at the Connecticut Ave. entrance of Rock Creek and Potomac Parks, with in ten minutes of the center of the city." (White Border Era.)

This 1967-postmarked card of the Sheraton Park and Motor Inn (2660 Connecticut Avenue) boasts "1464 guest rooms, all with bath and air conditioning. Free radio and television. Outdoor swimming pool and ice skating rink. Family plan rates. Good food at reasonable prices. The only hotel in the world offering its own free train service to carry you around 16 acres of wooded grounds. Right in the heart of the city of Washington. Free Parking." (Photochrome Era.)

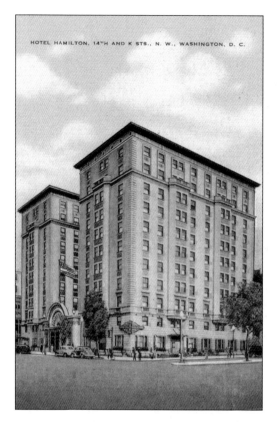

HOTEL HAMILTON, 14TH AND K STS., N. W., WASHINGTON, D. C.

The Hotel Hamilton, pictured on this "Natural Color Post Card," provides the following information on the card: "[The] only hotel selected by the jury of architects to receive the medal for structural beauty award by the Washington Board of Trade's Municipal Art Committee. Rooms air conditioned. Circulating ice water."

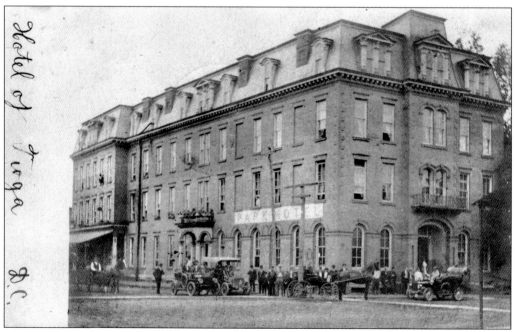

The sender of this card, postmarked March 9, 1907, has written Hotel of Tioga on the front of this card. A sign indicates that it has become the Park Hotel. (Postcard Era.)

116

The Fairfax Hotel, at Twenty-first Street and Massachusetts Avenue NW, is described as "A Hotel of Distinction in Washington's Finest Residential Section. Convenient to all Points of Interest. 300 Rooms and Baths. Clyde B. Douthat, Manager." The card is postmarked 1946.

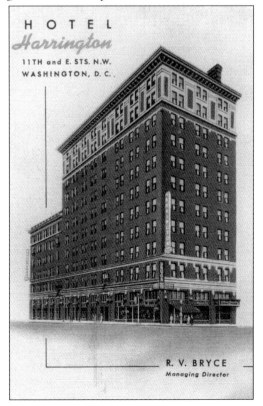

This 1944-postmarked card of the Hotel Harrington at Eleventh and E Streets NW boasts, "Midway between the Capitol and the White House. In the heart of all Business, Government and Amusement Activities. 300 Rooms—40 Sample Rooms—Hotel Completely Air-Conditioned. Radio in every room. Home of Kitcheteria." (Linen Era.)

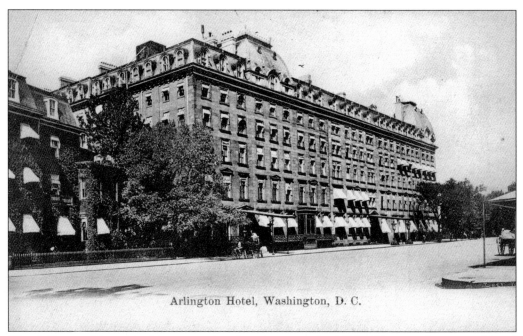

Arlington Hotel, Washington, D. C.

The Arlington Hotel was in a convenient location near the White House and was considered to be a luxury hotel. Architect Edmund Lind designed the structure, and architect Harvey L. Page designed the 1899 addition. The building was razed in 1912.

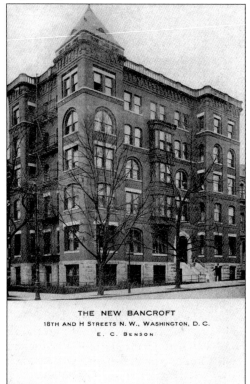

THE NEW BANCROFT
18TH AND H STREETS N. W., WASHINGTON, D. C.
E. C. BENSON

The New Bancroft Hotel was also located near the White House at Eighteenth and H Streets NW.

118

The Hotel Raleigh was located at Twelfth Street and Pennsylvania Avenue NW. The postcard's reverse boasted that the hotel had "450 Beautiful Rooms with Bath. In the Heart of Washington, you'll enjoy modern luxury and service at the Raleigh." Built in 1898, the hotel was enlarged in 1905–1911. The architect was Henry Janeway Hardenbergh of New York. The building was torn down in 1964.

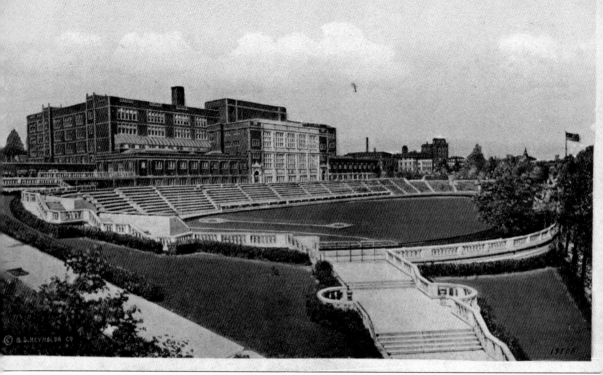

Central High School is featured on this postcard. The reverse includes the following information: "The Central High School is one of the largest and most modern institutions of its kind in the United States. It contains a large swimming pool where the pupils are taught swimming and life saving. The Stadium is used by all high schools for football games and athletic track meets. The large auditorium is used for public functions and Community Center activities. The stage is the largest in the city and the prescanium [proscenium] arch is one of the largest in the world." This is now Cardozo High School. (White Border Era.)

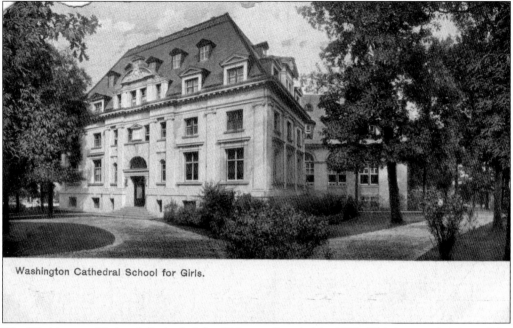

Washington Cathedral School for Girls.

The Washington National Cathedral for Girls was founded in 1900. This is an early view of the school published by the Leet Brothers of Washington. (Postcard Era.)

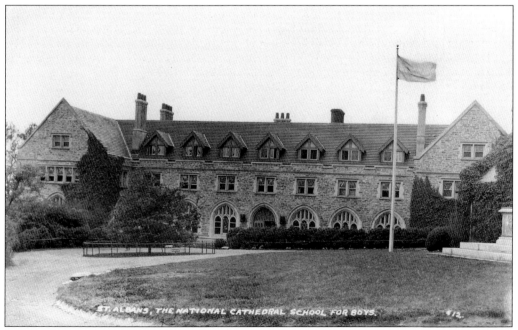

ST. ALBANS, THE NATIONAL CATHEDRAL SCHOOL FOR BOYS.

St. Albans, the National Cathedral School for Boys, was founded in 1907. This early view indicates that it is a photograph taken by W. R. Ross of 39 Que Street NW. (Postcard Era.)

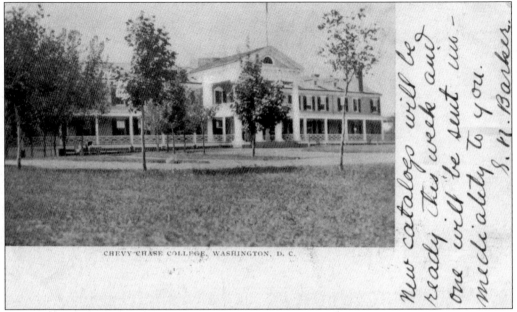

CHEVY CHASE COLLEGE, WASHINGTON, D. C.

New catalogs will be ready this week and one will be sent immediately to you. S. N. Barker.

Chevy Chase College for Young Ladies was at another time Chevy Chase Junior College. The college occupied the former Chevy Chase Inn. It is now the National 4-H Youth Conference Center. (Postcard Era.)

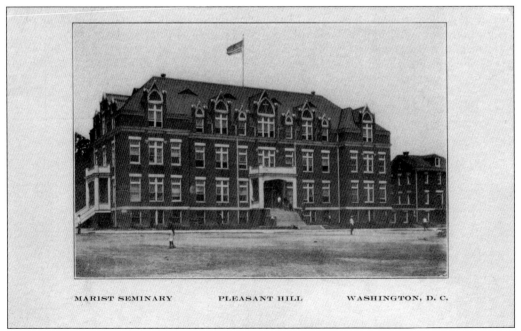

MARIST SEMINARY PLEASANT HILL WASHINGTON, D. C.

As Marist College, this building was used as a monastery for training monks in the Marist order. Marist College was established in 1891. The building is still in use by the Catholic University of America as headquarters for the School of Library and Information Science.

122

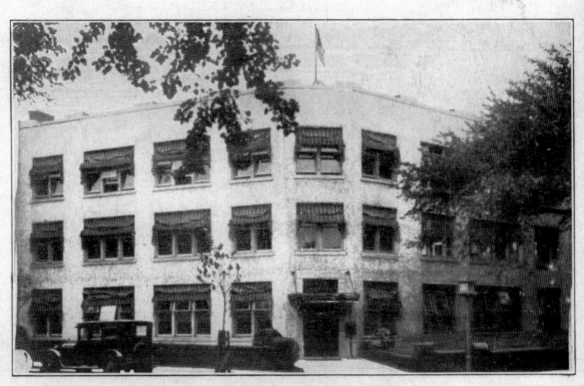

LEWIS HOTEL TRAINING SCHOOOL—23rd and Pennsylvania Ave., Washington, D. C.

The reverse of this postcard explains, "The building pictured on the other side is one of the 'High Lights' of Washington. The only school of its kind in the world, it contains all the equipment of a model hotel, complete in every detail so that Lewis training may be thoroughly practical—answering the present day demand for trained employees in hotels, clubs, schools, apartment houses, institutions, etc." (Divided Back Era.)

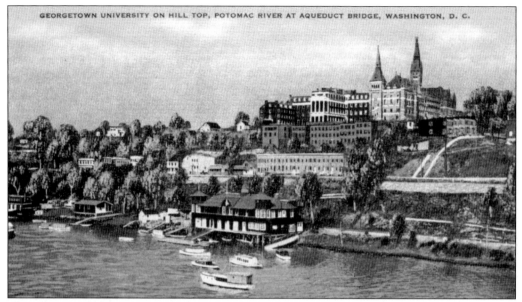

The explanation on the reverse of this postcard reads, "Georgetown Heights and Georgetown College. Georgetown of West Washington is the seat of Georgetown College, the oldest and largest Jesuit College in the Country. The first building was erected in 1789. The heights command noble views of the Potomac River and Virginia Hills."

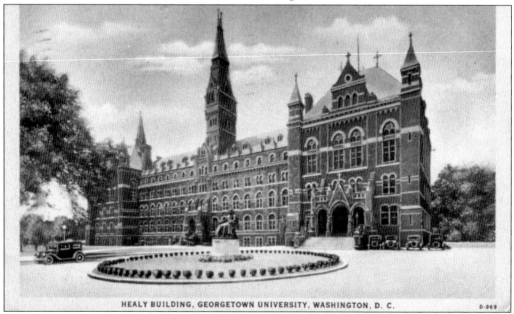

HEALY BUILDING, GEORGETOWN UNIVERSITY, WASHINGTON, D. C. D-969

This early postcard shows the Healy Building, which is named after Fr. Patrick F. Healy, Georgetown's president from 1873 until 1882. Education for males in America was of the most importance to him since he had to be educated abroad because his mother was a former slave and his father an Irish immigrant. The statue at the center of the postcard is that of Georgetown Academy founder Fr. John Carroll, who was appointed a superior of the American Mission by the pope in 1784 and saw a need for an institution to educate young American Republic Catholic males. He founded this school in 1789.

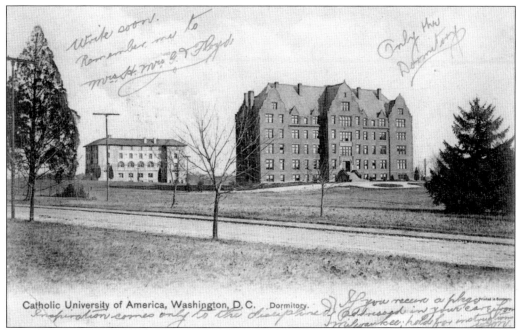

The United States Bishops founded Catholic University in 1887 as a graduate school and research center. The school began admitting undergraduates in 1904. (Postcard Era.)

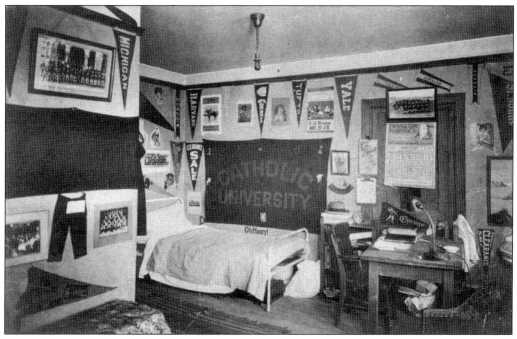

The Bureau of Engraving and Printing calendar in this dorm room appears to be turned to February 1925. Notice the unique lighting fixture in the room.

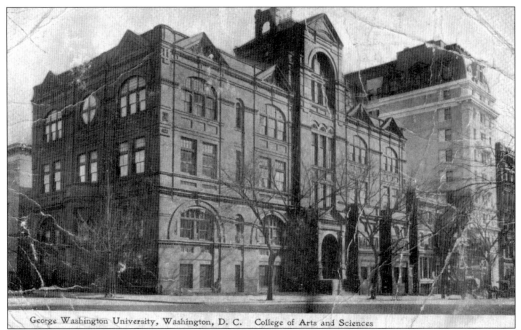

George Washington University, Washington, D. C. College of Arts and Sciences

This 1910-postmarked card of the George Washington University College of Arts and Sciences provides us a very clear view of the area at the time. Originally named Columbian College, George Washington University was founded in 1821 and had its first commencement in 1824. In attendance at that commencement, according to the school's web site, were Pres. James Monroe, John Q. Adams, and Revolutionary War hero Lafayette.

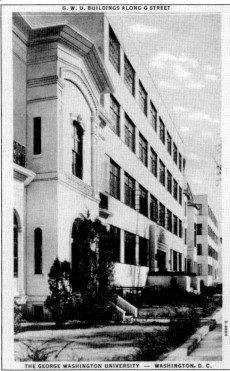

G. W. U. BUILDINGS ALONG G STREET

THE GEORGE WASHINGTON UNIVERSITY — WASHINGTON, D. C.

A more modern George Washington University is portrayed in this postcard that shows buildings along G Street NW. (White Border Era.)

SELECT BIBLIOGRAPHY

American Society of Civil Engineers, the Committee on History and Heritage of the National Capital Section. *Civil Engineering Landmarks of the Nation's Capital.* Washington, D.C.: American Society of Civil Engineers, 1982.

Caemmerer, H. Paul. *Washington the National Capital, Senate Report No. 332* (71st Congress, 3rd Session). Washington, D.C.: The Government Printing Office, 1932.

Cowdrey, Albert E. *A City for the Nation: The Army Engineers and the Building of Washington, D.C., 1798–1967.* Washington, D.C.: The Government Printing Office, 1979.

Craig, Lois and the staff of the Federal Architecture Project. *The Federal Presence: Architecture, Politics, and National Design.* Cambridge, MA: The M.I.T. Press, 1978.

Daughters of the American Revolution, District of Columbia, State Historic Committee. *Historical Directory of the District of Columbia.* Washington, D.C.: State Historic Committee, District of Columbia, Daughters of the American Revolution, 1922.

Duryee, Sacket L. *A Historical Summary of the Work of the Corps of Engineers in Washington, D.C. and Vicinity, 1852–1952.* Washington, D.C.: Washington Engineer District, 1952.

Evelyn, Douglas E., and Paul Dickson. *On This Spot: Pinpointing the Past in Washington, D.C.* __Washington, D.C.: The National Geographic Society, 1999.

Gatchel, Theodore Dodge. *Rambling Through Washington: An Account of Old and New Landmarks in Our Capital City.* Washington, D.C.: The Washington Journal, 1932.

Goode, James M. *Capital Losses: A Cultural History of Washington's Destroyed Buildings.* Washington, D.C.: The Smithsonian Institution Press, 2003.

———. *The Outdoor Sculpture of Washington, D.C.: A Comprehensive Historical Guide.* Washington, D.C.: The Smithsonian Institution Press, 1974.

Green, Constance McLaughlin. *Washington: A History of the Capital, 1800–1950.* Two Volumes. Princeton, NJ: Princeton University Press, 1962–1963.

Gutheim, Frederick, assisted by Antoinette Lee. National Capital Planning Commission. *Planning Washington 1924–1976: An Era of Planning for the National Capital and Environs.* Washington, D.C.: Smithsonian Institution Press, 1977.

Junior League of Washington. Thomas Froncek, ed. *An Illustrated History: The City of Washington.* New York: Alfred A. Knopf, 1979.

Lee, Richard M. *Mr. Lincoln's City: An Illustrated Guide to the Civil War Sites of Washington.* McLean, VA: EPM Publications, Inc., 1981.

Miller, Frederic M., and Howard Gillette Jr. *Washington Seen: A Photographic History, 1875–1965.* Baltimore, MD: The Johns Hopkins University Press, 1995.

Mitchell, Alexander D., IV. *Washington, D.C. Then and Now.* San Diego, CA: Thunder Bay Press, 2000.

Myer, Donald Beckman. *Bridges and the City of Washington*. Washington, D.C.: U.S. Commission of Fine Arts, 1974.

National Capital Planning Commission. Frederick Gutheim, consultant. *Worthy of the Nation: The History of Planning for the National Capital*. Washington, D.C.: Smithsonian Institution Press, 1977.

Nilsson, Dex. *The Names of Washington, D.C.: Who Were They? Why Are Their Names Honored Here?* Rockville, MD: Twinbrook Communications, 1998.

Reps, John W. *Monumental Washington: The Planning and Development of the Capital Center*. Princeton, NJ: Princeton University Press, 1967.

Roberts, Chalmers M. *Washington, Past and Present: A Pictorial History of the Nation's Capital*. Washington, D.C.: Public Affairs Press, 1950.

Scott, Pamela, and Antoinette J. Lee. *Buildings of the District of Columbia*. New York: Oxford University Press, 1993.

Society for Industrial Archaeology, Montgomery C. Meigs Original Chapter. Sara Amy Leach, ed. *Capital IA: Industrial Archaeology of Washington, D.C.* Washington, D.C.: Society for Industrial Archaeology, Montgomery C. Meigs Original Chapter, 2001.

Work Projects Administration, Federal Writer's Program. Randall Bond Truett, ed. *Washington, D.C.: A Guide to the Nation' Capital, American Guide Series*. New Revised Edition. New York: Hastings House Publishers, 1968.

Walton, William. *The Evidence of Washington*. New York, NY: Harper & Row, Publishers, 1966.

Washington, D.C., Committee on Marking Points of Historic Interest, 1921. *Points of Historic Interest in the National Capital*. Washington, D.C.: Published by the Committee, 1921.

Weeks, Christopher. *AIA Guide to the Architecture of Washington, D.C.* Third ed. Baltimore, MD: The Johns Hopkins University Press, 1974.